THE
pastel colour
WHEEL BOOK

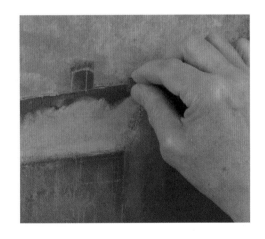

THE
pastel colour
WHEEL BOOK

john barber

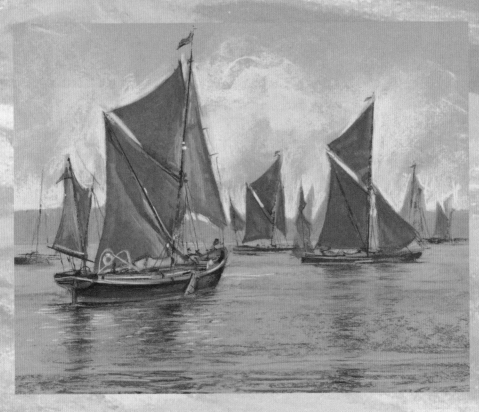

Search Press

First published in Great Britain in 2009 by
Search Press Limited
Wellwood, North Farm Road
Tunbridge Wells, Kent TN2 3DR

Created and conceived by
Axis Publishing Ltd
8c Accommodation Road
London NW11 8ED
www.axispublishing.co.uk

Creative Director: Siân Keogh
Editorial Director: Anne Yelland
Designer: Simon de Lotz
Production: Jo Ryan
Photography: Sean Keogh

ISBN: 978-1-84448-534-5

The publishers and author can accept no responsibility for
any consequences arising from the information, advice
or instructions given in this publication.

Readers are permitted to reproduce any of the material
in this book for their personal use, or for the purposes of
selling for charity, free of charge and without the prior permission
of the Publishers. Any use of the material for commercial purposes
is not permitted without the prior permission of the Publishers.

Suppliers
If you have difficulty obtaining any of the materials or
equipment mentioned in this book, please visit the Search Press
website for details of suppliers: www.searchpress.com

Printed and bound in China

contents

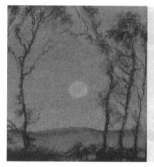

winter sunset

Capture the golden tones
of sunset through a
woodland scene by colour
blending and lifting out a
disk for the setting sun.

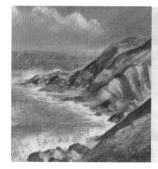

cliffs in sunlight

Mix and blend pastels to
create the ever-changing
effects of sunlight across
the sky and in the rocks,
vegetation and water.

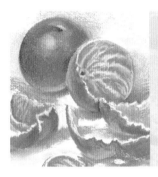

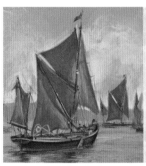

introduction

Do you remember the sensation of drawing on a pavement or wall with a stick of chalk? Or drawing on a chalkboard and feeling the rough surface wearing away the chalk? If so, then you will understand the simple facts of all pastel painting. We call it painting, but pastel is both a drawing and a painting medium, more so than other media: in wet media, the drawing becomes absorbed as the work progresses. With pastels you can be drawing right up to the finishing touches on your work. When our early ancestors picked up a piece of chalk or red earth and found that their marks could be ground into the rock walls of their caves, they had discovered the principles of pastels. The great joy of pastels is the simplicity and lack of complication in their use. There are no liquids or mixing equipment, no brushes, no drying times, no stretching of canvas, or unscrewing tubes and no palettes. Just pick up a pastel and start drawing on any kind of paper at any time. Pick up another pastel and you have begun to paint. You will not have to wait for it to dry, it will not change colour or darken and can easily be altered.

Another attractive thing about pastels is that all your lovely vibrant colours are laid out for you to see and they will stay exactly the same colour when they appear on your picture. By twisting the pastel between your fingers and stroking the paper in different directions, you will begin to get the feel of this delightful medium. There are drawbacks: the dangers of smudging and having to buy many shades in each colour. But all art media have some disadvantages. The plus points for pastels are the ease of handling, the vibrancy of the colours and speed of execution.

Pastels gained much of their popularity in the 18th century, mainly as a portrait painting medium. One of the first artists to work entirely in pastel was Rosalba Carriera (1675–1757). The leading Venetian portraitist of her day,

she also had great success in France and probably impressed three leading pastel artists of the next generation – Jean-Etienne Léotard (1702–1769), Maurice Quentin de la Tour (1704–1788) and Jean-Baptiste Perronneau (1715–1783). They all specialised in the art of portrait painting. Edouard Manet (1832–1883) produced many charming works in pastel, as did Pierre-Auguste Renoir (1841–1919), but it is to Edgar Dégas (1834–1917) that we must look to for major works carried out entirely in pastels. He is the outstanding master of the medium. Study him if you can, but the great thing about pastels is that without technical knowledge they can make attractive images for you from the slightest of techniques. Think about what your favourite subject is, what you really like looking at, then you will really know what kind of artist you are. Pick up that pastel and begin to find out.

understanding colour

What the great artists showed is that successful pastel painting often depends as much on the effects created by your colour choice as on composition, which is where an understanding of how colour works comes in. Look at the colour wheel (right) to see how colours are grouped. For

THE COLOUR WHEEL

The colour wheel is great reference for artists. The three colours in the centre are the primary colours. Primary colours are the ones that cannot be obtained by mixing other colours together. The middle ring shows the colours that are created when you mix two of the primaries. Red and yellow makes orange; blue and yellow makes green; blue and red makes purple. These are called secondary colours and show the colours you can expect to create when you mix primary colours. All colours can, in theory, be created by mixing varying amounts of the primaries. The outer ring breaks down the secondary colours further into 12 shades.

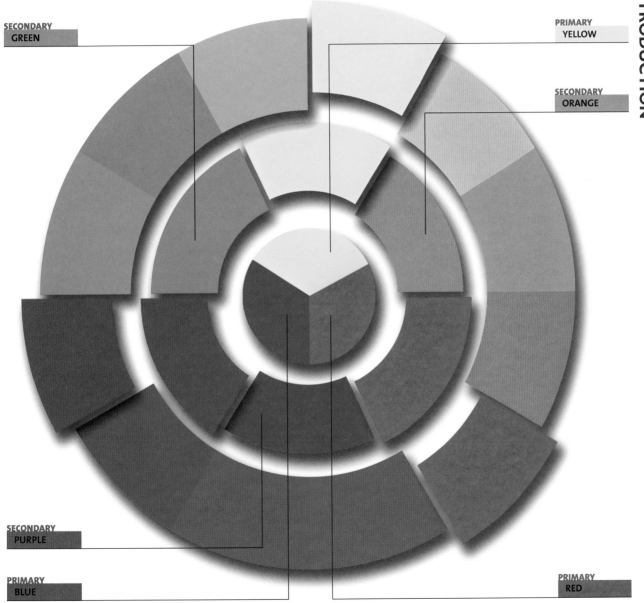

SECONDARY
GREEN

PRIMARY
YELLOW

SECONDARY
ORANGE

SECONDARY
PURPLE

PRIMARY
BLUE

PRIMARY
RED

COMPLEMENTARY COLOUR

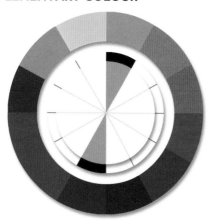

The colours that are opposite each other on the colour wheel are called complementary colours. These work together to create a harmonious reaction. Try using them side-by-side in your work – they will each appear to be stronger by contrast, bouncing off each other.

COLOUR TERMS

HUE
Hue indicates the strength of a colour from full saturation down to white. In practical terms, if you buy any colour labelled 'hue' it means that the colour is less than full strength. This is used as a way of reducing the cost of expensive pigments.

TONE
Tone is the degree of darkness from black to white that creates shade and light. For example, in a black-and-white photograph you can see and understand any object independently of colour, solely by its graduation from light to dark. The word 'shade' is often used instead of 'tone'.

COLOUR
Colour results from the division of light into separate wavelengths, creating the visible spectrum. Our brains interpret each wavelength as a different colour. The colour wheel is an aid that helps us understand how colours are arranged in relation to each other.

TRIADIC COLOUR

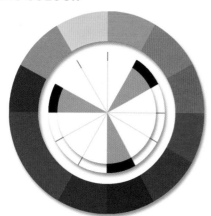

Triadic colour occurs when a 'chord' of three colours is used in combination. A mixture of any two colours of the triad used next to a third, unmixed, colour will give many different effects. A triad of colours from any part of the wheel is the basis for a good colour composition.

SPLIT COMPLEMENTARY COLOUR

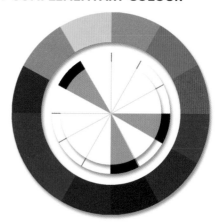

Split complementaries create three colours: the first colour, chosen from any point on the wheel, plus the two colours that come on either side of the first colour's natural complementary colour. These three colours will give plenty of unexpected colour schemes.

each picture you paint, you will need a watercolour to represent each of the primary colours so that by mixing them, you can obtain all the secondary colours. The primary colours you choose should be determined by the scene you wish to paint. For example, if you are painting cool clear skies and distant hills, choose cobalt blue to represent blue in the colour wheel; permanent rose to represent red; and cadmium lemon to represent yellow. All three colours are cool, enabling you to maintain a consistently cool palette – no clashing 'hot' colours will appear. Likewise, when painting a warm scene, use a warm blue, red and yellow for your primaries. This idea, along with using complementary colours, which appear opposite each other on the colour wheel and produce harmonious contrasts, will help you keep your colours balanced.

A good exercise is to make your own colour wheels for warm and cool colours. Draw several circles 4in (10cm) in diameter and divide each circle into six pie slices. Paint your three primaries in alternate slices and then mix them: red with yellow for orange, blue with yellow for green and blue with red for purple. Place these secondary colours in between the primaries and you will see exactly which ones work out well for your picture. Keep this worksheet as a reference palette.

taking style cues

Look at all artists' work, old and new, for ideas and inspiration. Research as many examples as you can, learning each artist's methods and techniques. This does not mean that you should try to produce exact copies of their work, but by your review you will develop your own knowledge and taste.

This book goes hand-in-hand with your own research by providing a wealth of instruction on just what can be achieved with pastels. Highly accessible, practical and instructional, what you will gain from it in technical skill will give you the competence that leads to confidence. It is this confidence that will enable you to express your thoughts in paint – it is easy to forget in the struggle to master materials that the real aim of painting is the expression of ourselves. Good technique and practical skill make this expression easier.

INDOOR/OUTDOOR TEST

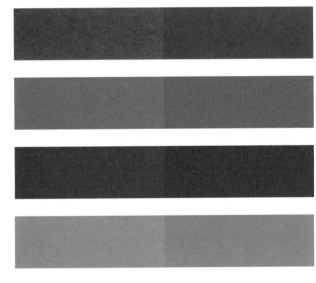

The indoor/outdoor test is designed to show the effect that artificial or subdued lighting has on colours when compared to daylight. If you look at the four strips indoors you can see hardly any difference between the colours on the right compared to the ones on the left. Step out into the daylight and you will be able to see that the right-hand side is noticeably darker. This sort of phenomenon plays an important part in how we perceive colour and all artists have to be aware of it. Although it is never quite as obvious as in the experiment, it does help to explain why art studios are built with high skylights, ideally facing north. For artists whose pictures depend on great colour accuracy, good daylight is an essential need.

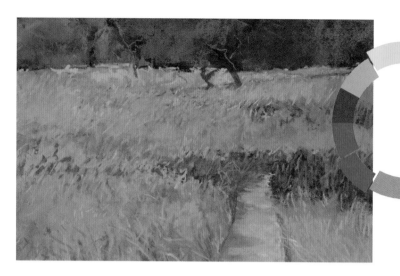

The grasses in this meadow glow pink with seedheads, captured by the lively pastel lines orchestrated by the artist to lead us into her pleasant landscape. A warm glow from the reds pervades the scene.

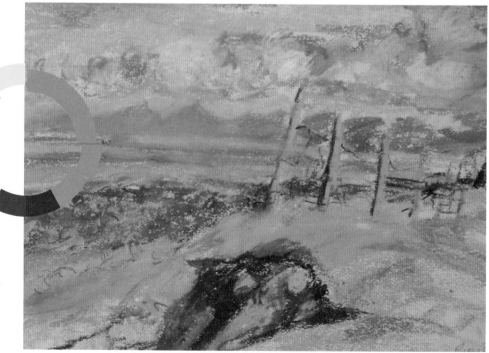

The fresh relaxed handling of the pastels is exactly what is needed for this visual record of a clifftop view. This is a sketch to blow away cobwebs in the mind. The power of the blues tip the balance toward the cool end of the palette.

The interlocking shapes of the sheds and houses share the crowded seafront scene with figures, boats and beach. Each element is designed into its place. The ochres, browns and pinks combine to form a warm but restrained range of colours.

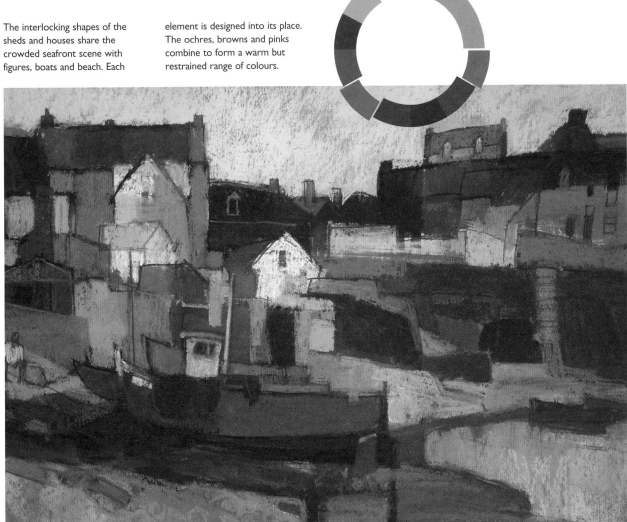

how to use this book

The jacket of this book features a unique colour-mixing wheel that will show you the shade that will result when you mix equal quantities of two colours. The colours have been chosen as the ones that are most useful to artists working in pastels. A glance through the projects in this book will give you an indication of the enormous range of colours and tones that can be achieved using these colours. Each project lists the colours you will need and highlights how to mix them to achieve the shades used in the project.

USING THE COLOUR-MIXING WHEEL

The colour-mixing wheel can be used to help you determine what the result of mixing any two colours from your selection will be. It can also be used if you are unsure of how to achieve a shade you wish to create, from nature for example. Turn the wheel until you find a shade in one of the inner windows you like and read off the two colours you need to mix to achieve it.

THE
pastel colour
WHEEL BOOK

1 turn the wheel to align the desired colour combination

2 the resulting colour will be seen in the indicated window

eight step-by-step pastels projects and a unique pastels mixing wheel

john barber

outer colour wheel
The colours on the outer wheel are the standard pastel colours you will need to get started.

inner colour wheel
Colours on the inner wheel repeat those of the outer wheel.

mixed colour
This window reveals a swatch of the exact result of mixing equal quantities of the colours on the inner and outer wheels.

turn the wheel
The wheel turns so that you can line up the two colours you intend to mix and see the result in the window.

finished painting
The project begins with the completed painting to give a sense of its overall scope and complexity. This is then broken down into several steps, gradually building the work.

picture details
The title of the finished piece of work, together with the artist's name are given. Also included is the size of the work, to give you an indication of scale.

what you will need
All the materials and equipment you will need to complete the project are highlighted at the start so that you can have everything to hand.

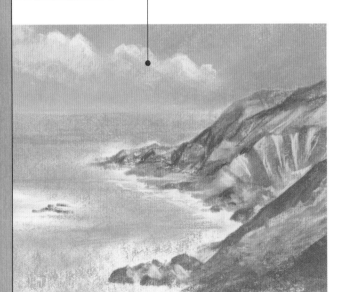

65

2

cliffs in sunlight

john barber
250 x 200mm (10 x 8in)

Cliffs, rocks and sky are good subjects for trying out many kinds of textures and shapes, from smooth blending in the sky and clouds to broad strokes made with the edge of the pastel sweeping across the picture and revealing the grain of the paper, broken up by smaller marks, building the illusion of sunlit rocks. Light in nature is always changing. If you paint outdoors (and pastel is both painting and drawing), you will soon find how often you have to adjust your contrasts. Go out with a box of pastels and a small pad of paper to look at nature and interpret it in your own way. With the skills you have learned from the projects, you will realise how quick and easy pastel sketching can be.

WHAT YOU WILL NEED
Rough surface watercolour pa
Torchons
Tissue or rag

COLOUR MIXES
1 Payne's gray
2 Viridian
4 Yellow ochre
7 Orange
10 Violet
11 Cobalt blue

TECHNIQUES FOR THE PROJECT

Whole-pastel painting

Using paper texture

techniques for the project
Different techniques are used in every project to build up your experience and confidence.

colour mixes
The colours used in the project are shown, together with the colours they are mixed with, to create the finished work.

14

project techniques
Each project begins with an explanation of one of the main techniques that will be used to create the picture, with notes to help you to achieve good results when using it.

detailed working
Close-up photography allows you to see every line and mark the artist makes to build up the practice study.

cliffs in sunlight / techniques

USING THE PASTEL AS A DRAWING TOOL

Pastel is as much a drawing as a painting medium. The way that the marks are made gives a distinct graphic definition. This can be preserved as a stylistic decision so that you may decide to lay your marks one upon the other like tiles until the image becomes recognisable. Just as many oil painters use wide flat brushes to make square marks side by side to achieve a distinctive style, so you can restrict yourself to pieces of pastel of the same length to give a consistency to your work. Limiting yourself to one colour at first and drawing the complete scene in lines is another approach which works well and can be carried out in any colour. Any area of colouring in pastel

can be treated in a graphic, rather than a painterly, way. By painterly in this context, we mean working in solid colours, blended into each other. Graphic treatment will involve many parallel lines of different colours, placed close together to give the illusion of a single colour. Lines will make the surface of the painting and the colour, because unblended, looks brighter. With this style, the coloured lines can still be used by their change of direction to model the form. Always remember the shape under the colour. Dégas, in his later work, gives us a better insight into his methods because his marks got bigger and more free. His pastels were always another aspect of his obsessive desire to draw.

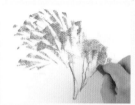

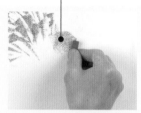

3 These marks can be superimposed one on another, rather than all being worked side by side. This helps you to build up light and darker marks. Keep some light and sketchy and make others stronger in colour.

4 Lift the pastel and use the edge to do some linear work. Look at the marks you have made and see if they suggest a form to you. If they do, then work on them some more. Here the shapes suggest a plant or tree.

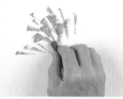

1 Holding the length of the pastel between your finger and thumb, put your finger and thumb on the paper and twist the pastel through around 30 degrees to get a wedge shaped mark. Repeat this several times on your paper.

2 This enables you to create similar shapes. Keep the end of the pastel twisting slightly as it touches the paper. However slight the movement you will get a coloured shape on the paper with one small twist of your finger and thumb.

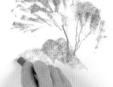

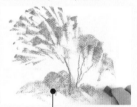

5 Then use the pastel on its side and pull it lightly across the paper to create a sense of the ground, anchoring the tree in space. Pull the side of the pastel to give an area of solid, pale tone as you build up your little sketch.

6 This simple study needs no further elaboration it demonstrates three different ways of holding your pastel and manipulating it to make marks: twisting on the paper for wedge shapes, on its edge for lines and on its side for the ground.

practice sketch
Each techniques spread features a quick step-by-step study enabling you to practice the technique.

finished study
The study builds into a finished sketch. You could practice this several times in different colours before embarking on the project.

step by step
The project is built up in detailed steps right from the first sketched marks to the finished piece of work, enabling you to create a work of your own using these techniques.

detailed practice
Practical photographs of good working practice in using materials show the artist building up the work.

artist's advice and tips
A practicing artist offers information and advice based on his experience of materials and equipment and methods of working.

74

2

cliffs in sunlight

75

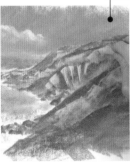

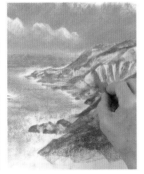

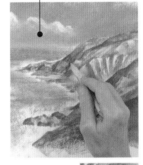

Continue to build up areas of light on the rocks before progressing to work on the sea. Add more light grey until you are satisfied with the colour.

RIGHT Use the tip of the pastel and a feathering technique, to work more definition into the sea where it meets the rocks.

Now you can return to the darker areas of the picture. Work some blue into the shadows of the cliffs, to give the impression that the sea is being reflected up onto the rocks.

GOING BACK
If your picture begins to get too heavy and overworked, try laying a sheet of soft paper over your work. Fix it with tape so that it does not slide and rub firmly over the back. This will lift the pastel evenly so that what is left will be a paler version for you to start working on again.

Using the Payne's gray pastel, add some deeper shading to the rock faces that are in shadow. You can use the torchon, if you prefer, to work some of the colour deeper into the crevasses.

RIGHT Blend the dark grey back with the torchon if it begins to look too stark.

Stand back from your work to consider the drawing as a whole and carry out any final blending with the torchon. Use the white pastel to add a few highlights around the sea edge, but avoid areas where the texture and colour of the paper are still showing through, as the white pastel is a different colour from the white paper.

FIX IT
You can use a fixative spray to stick powdery pastels to your support and spray as often as you wish. At first it will darken the colour but as it dries the colour will return, although not quite as bright and sparkling as before. Work over the picture again to regain crispness of colour and do not spray the final touches.

STEP 13 **STEP 14** **STEP 15** **STEP 16**

pull-out detail
For clarity, some areas of the work are highlighted in greater detail, enabling you to see exactly what shade or effect you are looking for.

clear steps
Each project builds up in numbered steps, with precise details on what to mix and how to add colour and detail.

guided steps
All the steps are clearly outlined, as the project builds up. Following all the steps results in the finished picture.

materials & equipment

Artsts who work with pastels need very little to get started in the medium. This section explains what you need in order to achieve successful results and examines the range of materials you will find in your art store or online. Pastels, pencils, papers, brushes and all the essential accessories are fully illustrated.

materials and equipment

Pastels are made by grinding fine pigments into an inert binder. The pigments used in their manufacture are exactly the same as those used in other painting media: the difference lies in what is used as the binder. Watercolours are bound with gum arabic, oils with linseed oil and pastels are bound with gum tragacanth (in fact, the word pastel derives from *pastelo*, the Italian word for gum).

The way pastels are manufactured is that the mix starts with pure colour, which is then progressively 'cut' with an equal quantity of white. This new, paler tone is again cut with an equal amount of white and so on. This gives the wonderful range of colours that you see in a large box of pastels. Both hard and soft pastels (the type used throughout this book) are made in the same way: hard pastels have a higher percentage of gum binder to hold them together and are cut with quantities of black rather than white. The higher proportion of pigment to binder in soft pastels is responsible for their bright and vibrant colours.

box sets or individual sticks?

Soft pastels are generally sold in either box sets or as individual sticks. If you are new to them, buy a set containing as many pastels as you can afford. The ease of working offered by having the precise shade you need immediately to hand cannot be over-emphasised. As your pastel

A box of square pastels in several shades of the colours you use most often is a good investment. A sturdy box keeps everything in the same place and a foam lining helps to avoid accidental damage to your sticks. Some box sets include a pad of pastel paper, to get you started.

painting career develops, you will probably want to add individual sticks to your collection. You will find that you use some colours and shades far more quickly than others.

Your other main choice when buying pastels is whether to choose round or square-sectioned ones. It is probably worth buying a few of each and experimenting with making marks using both types to see which you find easier to work with and which express what you want to convey in your paintings best. When you have made your decision, opt for a box set of whichever type works best for you.

pastel pencils

Pastel pencils are made from the same chalky pigments as pastels but are made harder so that they are not crushed when drawing pressure is put on them. Like pastels, they make soft powdery marks which can easily be blended with a torchon or your fingers. Many artists use fingers almost instinctively as sensitivity of touch is more direct. Different areas of the hand such as the flat thumb or the

BUYING THE RIGHT PASTELS

All the projects in this book and all the basic techniques of using pastels are completed using soft pastels. These have a high proportion of pigment to binder, are crumbly, rich and vibrant and available in an enormous range of colours and shades. They are easy to blend and smudge and can be used to create beautiful, chalky paintings.

The other common type of pastels are known as oil pastels. In these pastels, the pigment is bound in oil. They can be built up almost to a buttery texture and are ideal for quick sketching. They can also be brushed around on a support when moistened with turpentine or white spirit.

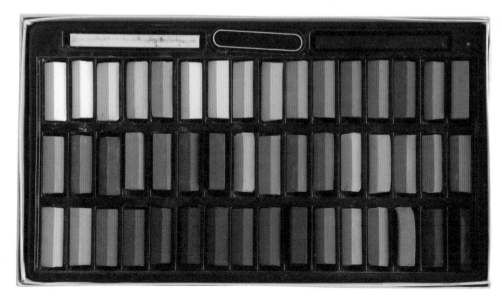

The longer your pastel sticks, the greater the area of colour you can put onto the paper, using them on their side. If you do not want to invest in a large box of long sticks, buy some basic colours as whole sticks and choose half sticks of less common shades to augment your colour selection.

outside of the little finger and even the side of the hand for large areas, are instantly available. Also your fingers can feel the texture of the paper surface. This will guide you in judging just how much rubbing your paper will need.

Careful storage is important with pencils as their leads are brittle and fracture easily, which is wasteful.

papers

Pastels can be used on almost any kind of paper or card and on many other surfaces such as linen, canvas and even wood. Papers that have a linen or canvas surface embossed on them can be useful and give a 'tooth' for

ABOVE You may prefer to buy your pastel sticks individually, rather than in a boxed set, which may contain some colours you will never use. If you put a selection together yourself, you can choose the precise shades you need for the type of work you have in mind.

LEFT Large, round pastels give good coverage for large areas of your paintings. Break these down to more manageable sizes for smaller areas of colour. You can leave any crumbs they deposit to make a contribution to the finished painting, if you wish. If you find that they are distracting, simply blow or brush them away.

LOOKING AFTER YOUR PASTELS

Soft pastel sticks contain more pigment and less binder than harder varieties. This makes them lovely to work with, but they do break easily.

Many manufacturers produce boxed sets of pastels and these offer a practical way of organising and storing your pastels. If you keep them in the original box, in their individual grooved supports and replace colours as you use them up, accidental breakage should not be a problem. Many boxes hold a selection of full and half sticks with spaces to store both.

If you find that your box is not big enough to hold all your colours – and as you develop as a pastel artist, you will realise that you need more and more colours to get the subtle nuances of colour you want – you will need to get a bigger one. Try to choose a box or tin that will hold your colours in a single layer: the more you stack them one on top of the other, the greater the chances of breakage. If you have to stack them, put a layer cardboard or bubble wrap between layers.

If you are using pastels for sketching when out and about, it is worth taking a bag or box for storage.

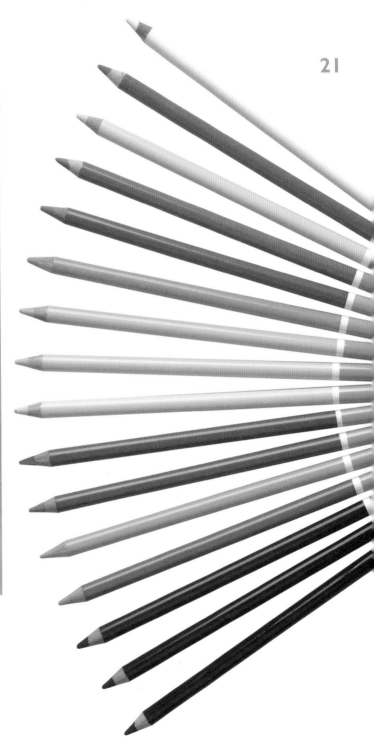

RIGHT Pastel pencils are as easy to control as graphite pencils, but offer the creative possibilities of soft pastel sticks. They are slightly chalky and can be sharpened to a fine point for detailed work. They have a soft texture and mix and blend well. Choose colours to match the pastel sticks you use most frequently and use them in your pastel drawings when you want to create detail, or clean up the edges of your drawing.

the pastel textures. Fine linen taped onto the drawing board, gives a unique drawing surface, as do certain fine-grained canvas boards. Gesso or polymer resin coated MDF boards are available in most art stores. They are a delightful surface to draw on and will give you the chance to experience the technique of the Old Masters.

Papers are available in a variety of textures, weights, colours and sizes and as individual sheets, pads and blocks. You can also buy ring-bound or perfect-bound sketchbooks. Papers usually range from 90 to 300lb; a good weight to start with is around 140lb. Watercolour

papers are available in three textures: 'hot press' is the smoothest and not very suitable for pastel work: 'rough' has the greatest texture so is ideal for pastels; 'cold press' or 'Not' has a medium texture and is a good general-purpose paper to start with.

There is a great range of treated and coloured papers and cards for you to sample. Cover papers and the boards sold for mat making are often good to draw on, especially the better quality ones that have a texture like linen. Try any types of papers that look promising and see what sort of results you get. Most art stores have pads of samples

RIGHT Pastel sticks are usually wrapped in paper. This has to be removed before you can use them. For work on large areas, use the pastel on its side. When you want to work smaller areas, break the stick in half or use a half stick.

SELECTING PASTEL PAPER

Many people choose to work on very fine sandpaper, sold mounted onto board or in sheets and rolls. These surfaces have a great deal of 'tooth' to hold pastel dust, allowing you to build up many subtle tones in the different layers of pastel you apply.

Velour pastel paper, also available in pads of white and assorted colours, is popular with some pastel artists. These papers vary in weight and texture and offer good colour adhesion.

Whatever type of support you choose, you always have the option of tinting it with watercolour before you start your pastel work. Having a toned ground gives you a good start in building up your pastel drawing.

that you can test your pastels on. With all of these surfaces available, you will have to find the ones that give you a good feeling as the pastels move about and helps to spread your colour freely.

The most commonly available range of papers made for pastels and colour pencils are Ingres or Canson. They have a surface designed to hold the fine grains of pastels. Experiment with both dark and light toned papers The darker papers exploit the chalky colours of pastels, with some even having tiny spots and fibres that add interest to

RIGHT There is a huge variety of coloured papers in very many textures that are suitable for pastel work. A coloured paper will influence how the pigments you apply will look. This can be used to great advantage in your work: you might choose an earth-coloured paper for a landscape or nature study, or a blue or green paper for a land or seascape.

your more decorative work. The tone or colour will affect and change the colour that you put on it. A white paper will show the brightest effects; a coloured paper will tone down all your colours, but help to harmonise them by pervading all your colours and bringing them closer together.

blending tools

You can blend your pastels on the paper using a variety of different materials. Some artists only use their fingertips, as this is obviously the most sensitive implement. The

STORING PASTEL PAPER

The best papers for pastel are expensive, so storing them carefully is worthwhile. Keep your papers flat in a dry drawer or cupboard – paper absorbs moisture from the air and this causes buckling. This can make small blocks of paper awkward to use. Sketch books are also less likely to buckle if laid flat. Stored properly, good paper can be kept indefinitely.

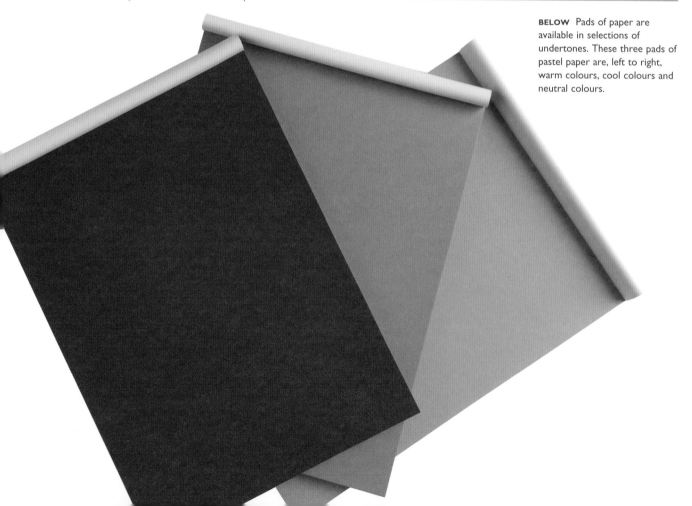

BELOW Pads of paper are available in selections of undertones. These three pads of pastel paper are, left to right, warm colours, cool colours and neutral colours.

Torchons are stumps of tightly rolled paper, which can be sharpened to a point. They are available in various thicknesses, the finer ones can be used to blend colour in detailed areas, the thicker ones for larger areas. Use cottonbuds for areas that are too small for a torchon.

Hoghair brushes in different sizes are useful for moving pastel around on your paper. With practise you will learn how much pressure to apply: you do not want to brush so hard that you damage the paper, but you do need to apply enough pressure to move the pigment.

drawback is that your fingers may be too big to blend tiny areas. For more controlled blending, you have three basic choices: brushes, torchons and cottonbuds.

Buy a couple of hoghair brushes in different sizes and reserve them for pastel work. The stiffness in the bristles will push the colour around on your paper to mix and blend. Torchons are rolled paper sticks that can be sharpened to a point. These are available in various thicknesses. Choose a couple of thick ones and use them on their side to blend large areas of pigment. Use thinner ones, sharpened to a pencil point, for finer details. For the tiniest areas, you may find cottonbuds are the most useful implement. All these blending tools will pick up colour. It is up to you whether you want to then use them as drawing tools, add to more colour tones to your work, or clean and sharpen so that you are always working with a pristine blending tool.

easels

If you are planning on working on large pieces, or on portraits, you may find it most comfortable to do some of the work standing. In that case, you will need to secure your work so that it does not wobble or shake. The classic studio easel has a ratchet mechanism, a tilting frame with winding handles and locking castors so that it can be wheeled around the studio, but for most people such elaborate pieces of furniture are unnecessary.

More usual and essential for serious work is the radial easel, which can cope with pictures up to 1m (3ft) square. A tripod sketching easel is adequate for most small pictures. The metal ones are more stable owing to their extra weight and rigidity, but less good for outdoor work. Camera tripods with a drawing board bolted to the camera plate are a good alternative. A desktop easel is useful if you prefer to sit at a table to paint and are working only on small to medium pieces.

BUYING THE RIGHT EASEL

You can work with your paper flat on a table top. However, an easel will help you to work in more comfort. When properly adjusted an easel will help to prevent backache and allow you to work freely. Any surplus pastel dust will simply fall to the floor.

Your choice of easel may well be determined by the space you have available. A tabletop model that folds away is a good choice if space is limited.

Think about your long-term needs when making your choice and buy the best quality you can afford: a good easel should last for many years.

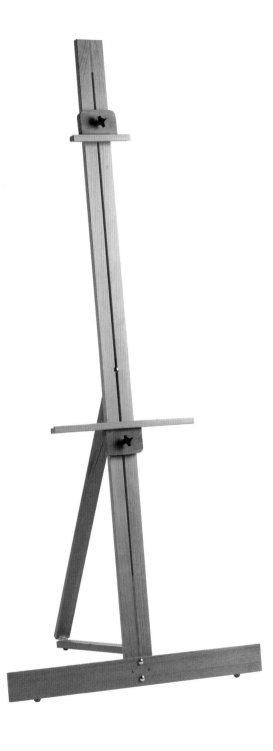

A tabletop easel is ideal for smaller works. If you are working on paper, tape your paper to a drawing board and lean on the easel. Choose a model with two or three angles of adjustment to meet your precise needs.

If you are going to be working on large pieces of work and in other media as well as pastels, a floor-standing easel is a good investment. An adjustable angle of working and adjustable legs, are good extras to look for in this kind of easel.

other useful equipment

A desk light is an essential for colour mixing in dim light and can also help you to orchestrate the lighting of your still life compositions. Blutack is useful for lifting out areas of colour and tidying up the edges of your compositions, as is a putty rubber.

Finally, in order for your pastel paintings to remain bright, you will need to fix the pastels: aerosol fixative is widely available from art stores. If you run out, in an emergency you can use hairspray as a fixative.

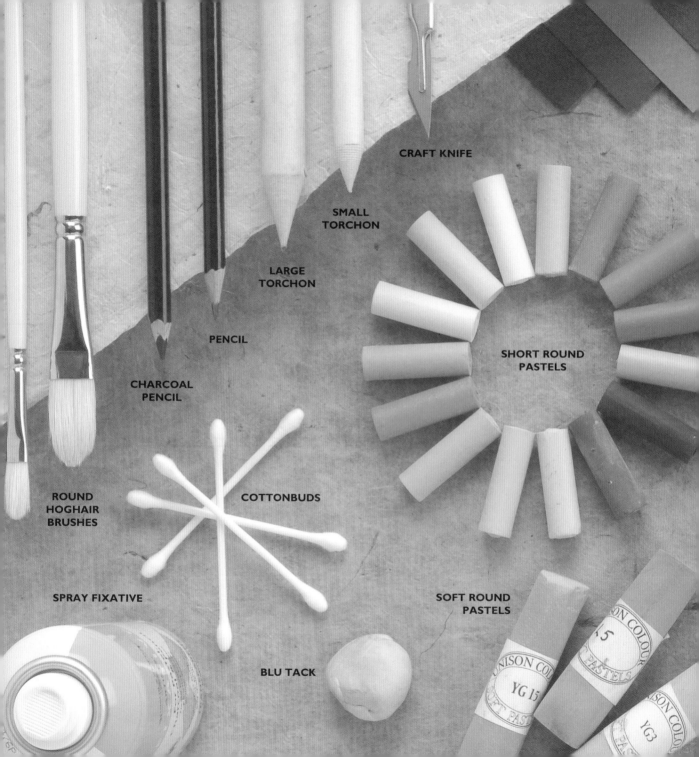

CRAFT KNIFE

SMALL
TORCHON

LARGE
TORCHON

SHORT ROUND
PASTELS

PENCIL

CHARCOAL
PENCIL

ROUND
HOGHAIR
BRUSHES

COTTONBUDS

SPRAY FIXATIVE

SOFT ROUND
PASTELS

BLU TACK

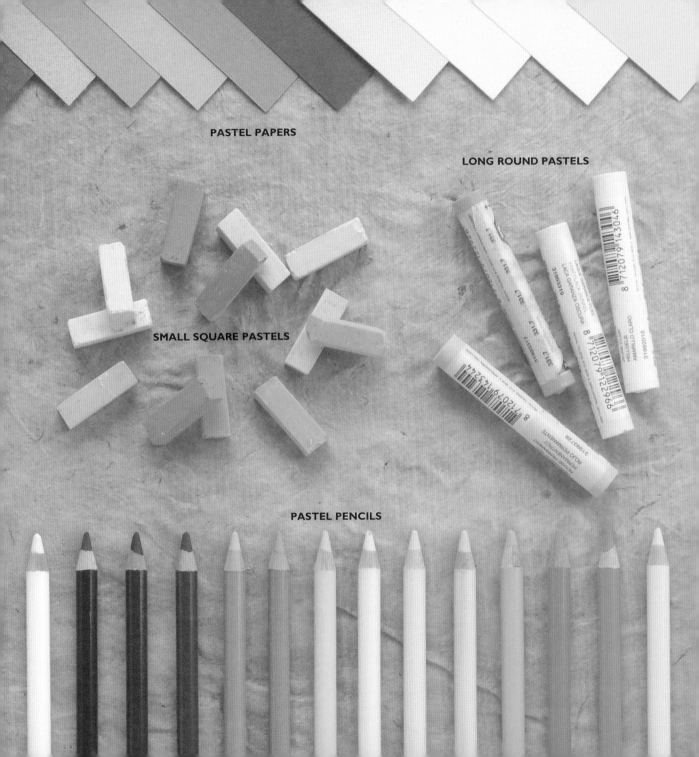

PASTEL PAPERS

LONG ROUND PASTELS

SMALL SQUARE PASTELS

PASTEL PENCILS

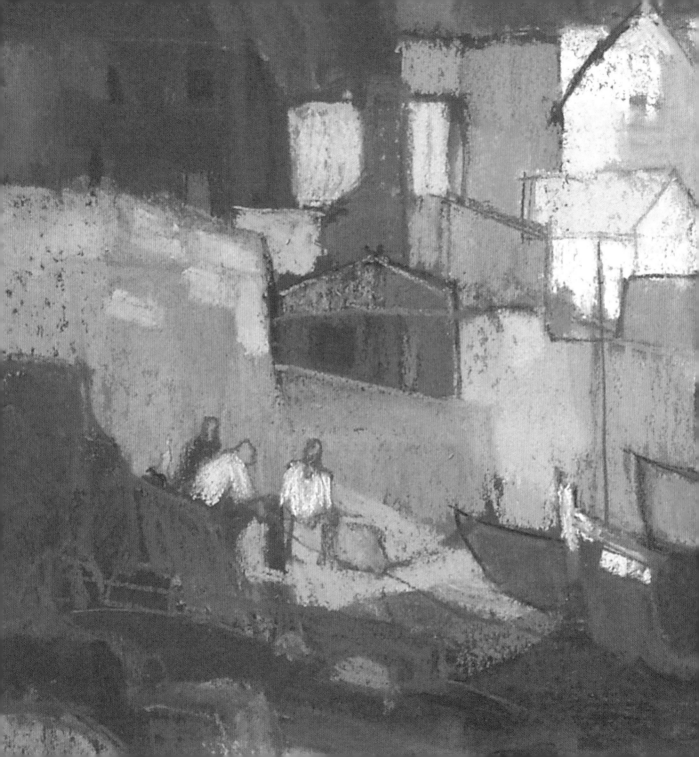

basic techniques

Before you can put pastel to paper, you need to know how and where to start. This section gives clear advice on the main pastel painting techniques: how to hold and manipulate your colours; controlling your marks; and mixing your colours. It also illustrates many of the innovative ways you can apply colour to paper.

basic techniques

In this technical section of the book, all the basic exercises needed to teach you the essential handling skills that will enable you to feel confident with the medium are described and demonstrated.

Start with your pastels laid out in neat rows of pristine colours and with their wrappers and names intact. Before you can start with pastels, you will need to do a brave thing. Take the pastel you intend to use first peel off the wrapper and break the pastel into several pieces. You will eventually have to do this to all your pastels. If you think that it would be a good idea to keep the wrapper on, to keep your fingers clean, forget it. Pastel painting is a dusty business and coloured fingers are inevitable. They will often become your most quickly accessible and sensitive tools.

Because the marks made by pastels are so immediately available, the crayon may become, as your skill grows, an extension of your hand which can both draw and paint. This is the aim of all art techniques, whatever the medium, but

HOLDING A PASTEL AND MAKING MARKS

How you hold your pastel is a very important part of how you paint. Practice different holds and marks to test their different effects. Do not use too large a piece at first, but practice holding a short piece with your forefinger on one end and your thumb on the other. Squeeze gently so that you have a firm grip, then press down on the paper and pull along in different directions. The other basic grip is to press down with your finger and thumb halfway along the piece of pastel. Try moving your grip to the end so that you can press only the far end of the pastel on the paper. This is also something that will teach you control of your marks.

1 Take a half pastel stick and, holding it top and bottom, drag it across the paper to make a broad sweep of colour. With the same stick, apply a second band of colour, this time pressing harder, then add a third with the lightest touch you can achieve.

2 Hold a square section pastel on two sides and use it to make lines. You can make quite fine lines in this way. If they are not fine enough for your finished drawing, however, you could use a pastel pencil instead in areas where you need fine detail.

CROSS-HATCHING

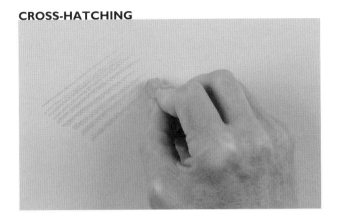

1 | Cross-hatching builds up colour. It can be used with one colour only to create an area of deep solid colour, or with two colours to make a third shade. Start by making a series of parallel lines. Try to make them as equally spaced as you can.

2 | If you then work across your first marks, you will create a more textured and blended look. Depending on your subject matter, you could leave the hatching with some texture, or you could blend the two colours together.

COLOUR BLENDING

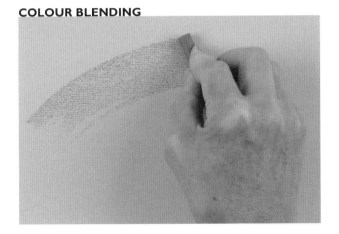

1 | Take a square-sectioned pastel and work across the paper to create an area of colour. You could go over this again if you prefer, but don't make the colour too strong. Don't press so hard that you risk damaging the paper surface.

2 | Then work a second colour over your first. This modifies your first colour. This is colour blending directly on the paper and is a demonstration of a technique that can be used to modify the shades you create in many of your pastel paintings.

since there is no intermediate tool between you and your picture, pastel comes closer more quickly than most other media to this ideal.

Firstly you must learn how to hold a piece of pastel in your fingers and control how much of the surface touches the paper and how and where to exert pressure. This is the most personal part since your touch on the paper is your unique experience. Be sensitive to the feel of the materials, respond to the grain of the paper and let it dictate the pressure of your hand.

colour selection

Since pastels are not mixed together before application and each pastel in any particular colour will only deliver one strength of colour, you need to have several tones of each, ranging from full strength down to very pale. The more gradations of tone you have, the easier it will be to

obtain your results. This means buying a lot of pastels, which can be expensive, but consider that, apart from paper, you have no other items to buy. Any saving will probably not compensate for the sheer frustration of being unable to choose the pastel you need. Basically, buy the most pastels you can afford and when you get started you will soon realise what extra colours you require for your kind of painting.

Pastels come in three basic types: soft, hard and pencils. Soft can be round or square in section and are often wrapped in paper to avoid breakages. This is more for presentation and holding the pastels together than for your benefit, because you are going to break them anyway. Hard pastels do not need wrapping and are sold in thinner, square-sectioned sticks. Included with these are drawing chalks, such as black, sanguine (brick red) and hard white chalk, which have the same format of thin,

STIPPLING

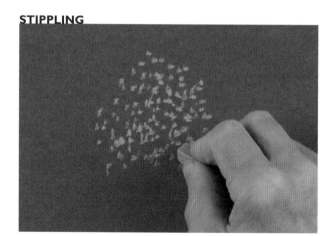

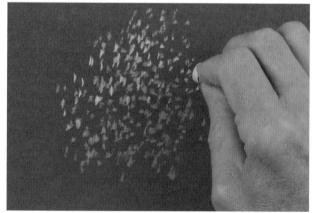

1 Bounce one colour in random dots onto the paper. Use the corner of the pastel and keep the angle of your hand constant so that you create lots of marks of the same size, shape and strength. You will probably have to blow the chalk away.

2 Then bounce a second colour around and between the first set of dots. Again, you will probably have to blow crumbs away. If the pastel breaks, simply continue with the piece that remains so that you do not lose the rhythm of your marks.

BLENDING USING A TORCHON

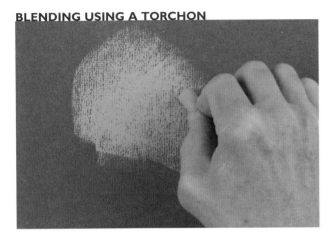

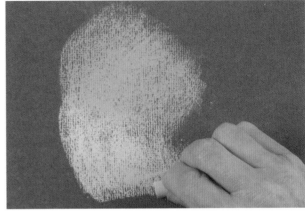

I A torchon is less sensitive than your fingers, but is useful when you want to blend over a large area. Lay down a circular area of pink, using the pastel on its side to create an area of fairly thick colour that is starting to obscure the texture of the paper.

2 Then work a similarly light tone of turquoise alongside the pink. Make part of your blue colour patch overlap your pink patch. and leave a clear area of blue and of pink. This type of exercise will prove useful in many of the projects that follow.

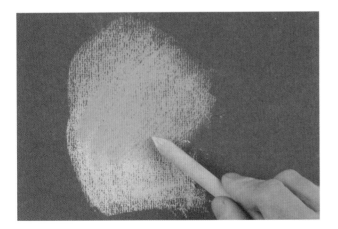

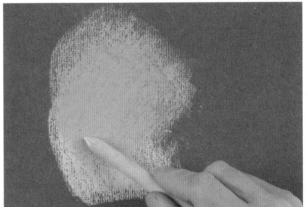

3 Then take a clean torchon and use to blend the two. Hold the torchon at an angle and begin to work across the colours. Work in a circular motion. This has the result of flattening the pastels' crumbly texture, as well as mixing the two colours.

4 As the torchon blends, it will pick up colour. You have two choices: either sharpen the torchon to get a clean point so that you are always using a white torchon, or use the colour on the torchon and work it into your colour patch too.

BLENDING USING YOUR FINGERS

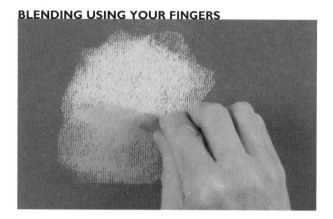 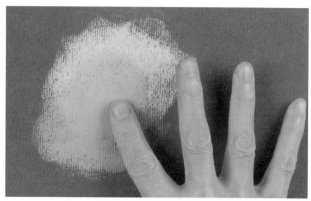

I Lay one area of flat colour, here a bright yellow, using the pastel on its side to get a good coverage on the paper. Then lay a flat area of another colour over the top. Here a blue-green was laid over the original yellow patch.

2 Use your finger to blend the two colours together. Your finger is probably your most sensitive blending tool. Through your finger, you can feel the tooth of the paper. Blend the colours to obscure that there were two colours initially.

FEATHERING

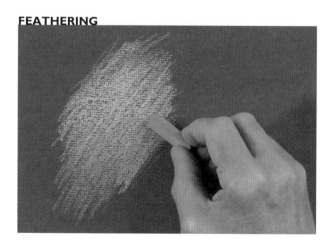 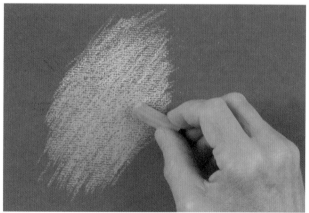

I Start with fairly solid colour in the centre of your piece of paper and feather it out to almost nothing. Use the edge of the pastel for feathering. Keep a light touch: at the edges of the feathering, use only one or two crumbs to add colour.

2 You can then feather a second colour into the first. The advantage of this technique is that you do not remove or move the colour that is underneath when you use feathering – both colours show through in the finished piece.

square sections. Hard pastels usually come in full-strength colour. Pastel pencils, where the coloured chalk is enclosed in wood in pencil form, have to be treated gently as although they are harder than most pastels, they will crumble under pressure and are quite difficult to sharpen, but they are useful for fine details.

controlling the crayons

First peel your pastel. Once you have taken off the paper wrapping, it will be ready for use. Soft pastels, with which most of the work in this book has been done, are either round or square in sections and the shape determines what marks you can make with them. Take a complete round-sectioned pastel and, holding it halfway along its length with your finger and thumb, squeeze it firmly and place it on your paper. Moving it sideways with the whole pastel in contact with the paper will give you a neat

rectangle of colour. If you place the pastel down again and pull it toward you, the result will be a straight, but probably quite a broad line. If you now hold the pastel at the end nearest to you and with firm pressure twist the whole pastel, while keeping the hand in the same place, you will draw a segment of a circle.

You can make similar marks using a square-sectioned pastel, but in this case, hold the two adjacent edges so that the right-angled edge of the pastel is the only part in contact with the paper. When you do this, a much cleaner line than you can get with the round pastel will appear. Practice these basic marks until you can predict what will happen, then break both types of pastel into pieces about 25mm (1in) long and do the movements again. By this point in your practice sessions, you should be able to create all sorts of studies using these basic marks.

MANIPULATING THE PASTELS TO GET SHAPES

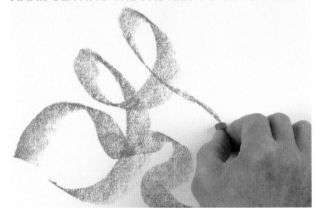

Use the side of a half stick of pastel and start to create a swirling pattern of marks. By varying the angle of your hand, you can influence the width and direction of the mark you make. Experiment with different colours and sizes of pastel stick.

DESCRIBING A CIRCLE

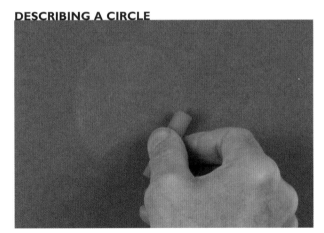

Hold the pastel on its side and move it around in a circular fashion. Keep the pastel on the paper and turn your wrist as far as you can. This is done in one stroke. You could also keep the pastel still and turn the paper around, if you prefer.

blending

An old artist once said 'all art is in the blending' and although it would be nice if things were so simple, blending certainly plays a big part in the art of pastel painting. The degree of smooth blending from one tone to another depends firstly on the paper surface and secondly on the tools used to rub one colour into another. For many artists, fingers are the most useful and convenient blending tools. For one thing, you do not have to go looking for them. For another, in most cases you have ten of them. Then, they have a ridged texture, ideal for moving dust. And, finally, they are easily cleaned for re-use. Also very useful are torchons, rolled up paper sharpened to a point. These come in several sizes so that you can blend tiny areas. When you move from one colour area to another, either sharpen your torchon to a clean point or have several new ones at hand. Do not rub too hard when blending, or you will lose too much of your colour.

fixing

Pastel is a delicate medium and your paintings may be damaged by accidental smudging and you may lose some colour. This means that a painting should always be fixed. You can use fixative at any point in a painting and then work over the area again to build up layers of colour, but do not spray your final work. Start spraying fixative off the picture surface then move across the surface smoothly from left to right. Allow to dry before continuing to work.

LIFTING A DISK OUT USING BLUTACK

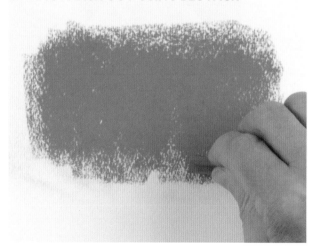

1 Lifting an area of pastel out restores the colour and texture of your paper. Lay down a flat area of pastel. Then, shape a piece of Blutack to suit what you want, in this case it was made into a circle so that a disk shape can be lifted out.

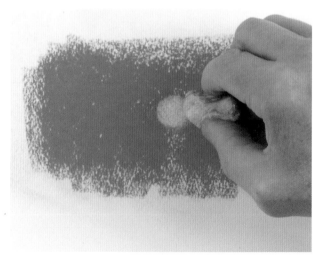

2 Dab at the pastel with the Blutack. The more grain in the paper, the longer it will take to remove the pastel. Keep moving the tack around to get a clean area after half a dozen or so dabs. Eventually you will lift out as much colour as you need. You could then work another colour into it.

LIFTING OUT AND TIDYING EDGES

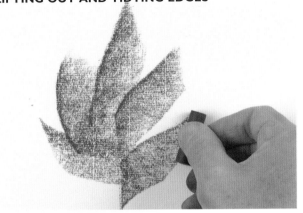

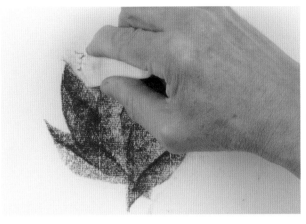

1 Draw your basic shape, in this case, a leaf was created using a dark viridian pastel. You can lift pastel off either with Blutack or using a putty rubber. Using a putty rubber allows you to remove pigment exactly where you need to.

2 Take the edge of the putty rubber and use it to clean up around the edges of your leaf drawing. Flick pastel off and blow the crumbs away. Work around all the blades of the leaf in turn, sharpening the edges and making them crisper.

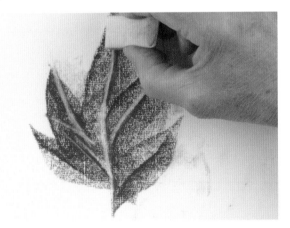

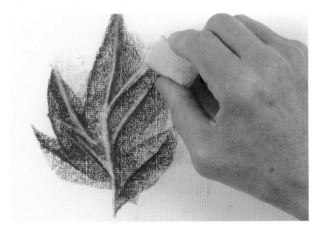

3 You can also lift out using the putty rubber. Cut it down to a suitable size and shape for your work, if you need to: a full-size putty rubber will be too large for lifting out more delicate details such as the veins on this leaf.

4 You can take out fairly precise lines, if you want to. Here veins are removed from the leaf shape, using the corner of the rubber. Practice lots of little studies like this one to get a feel for the pressure you need to apply to get the results you need.

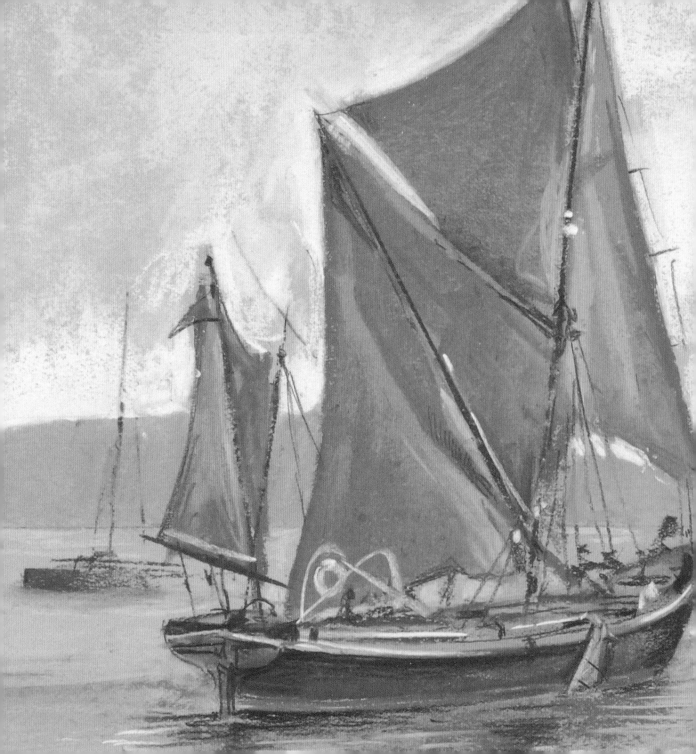

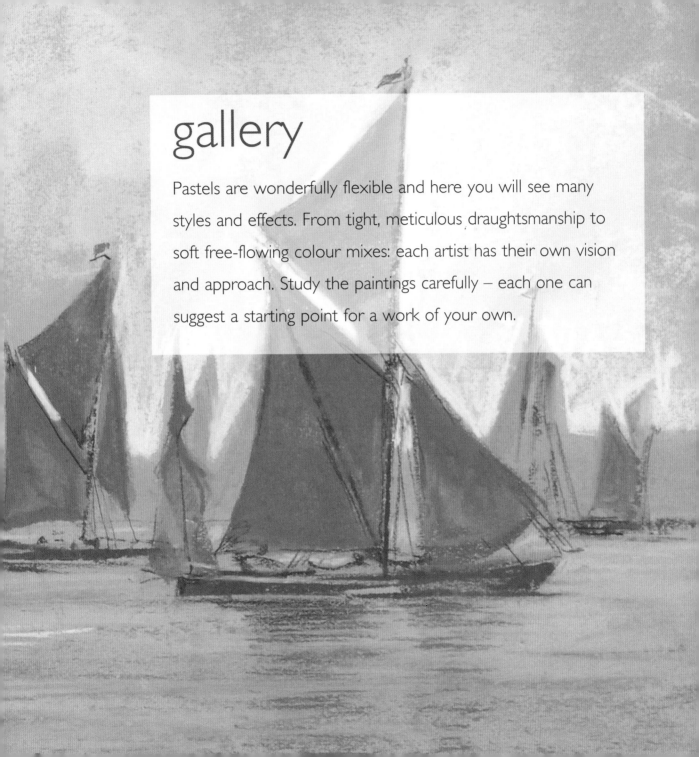

gallery

Pastels are wonderfully flexible and here you will see many styles and effects. From tight, meticulous draughtsmanship to soft free-flowing colour mixes: each artist has their own vision and approach. Study the paintings carefully – each one can suggest a starting point for a work of your own.

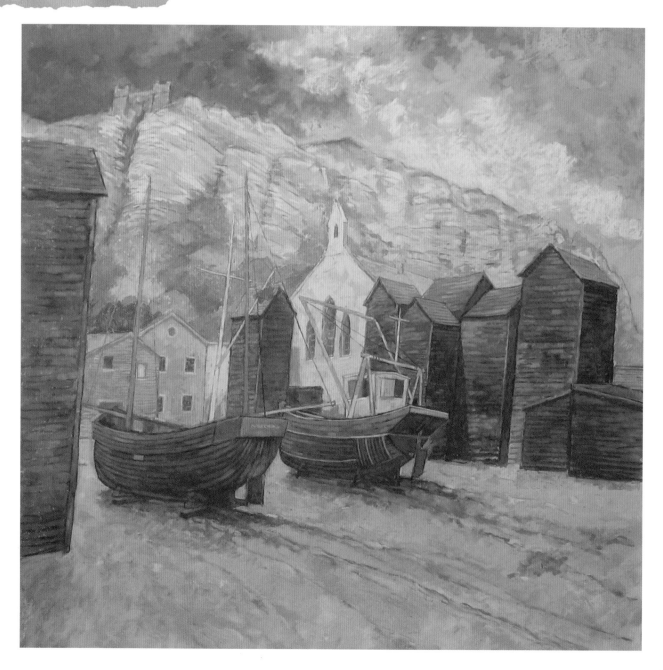

hastings
810 x 730 mm (33 x 30 in)
bob last

A fascinating combination of dark, tar-painted boats and net sheds enclose the white façade of the church. This picture has lively topographical detail in every part, from the swirling clouds and wooded cliffs to the ruts and shadows on the beach. The artist holds our interest with skillful control of the pastel medium.

breakwater and headland
430 x 430 mm (17 x 17 in)
cheryl culver

This simple but dramatic picture subdues the detail to concentrate our attention on the shimmering light mirrored off the sea. The dark headland neatly divides the sky from the sea and repeats the diagonal line of the beach.

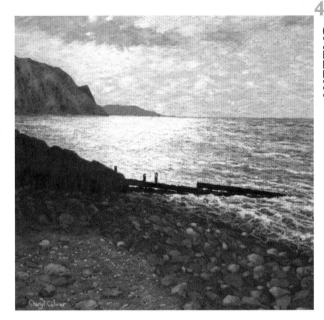

twyn
400 x 600 mm (16 x 24 in)
rima bray

Here the free use of the pastels give this impressionistic sketch a brisk, outdoor feeling. The immediacy of the marks, left untouched except where they blend in the distance, capture the clifftop view. The viewer can almost feel the breeze.

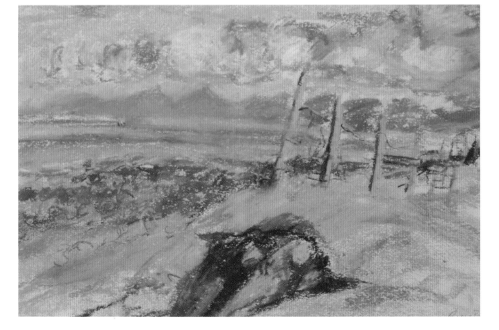

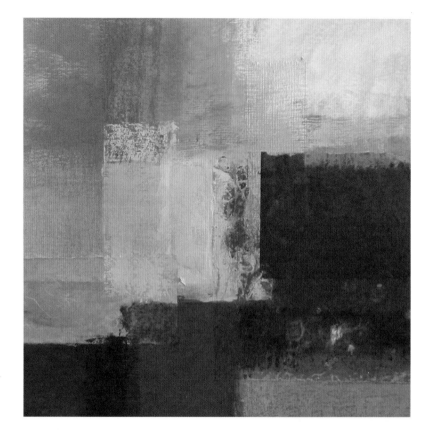

composition
500 x 500mm (20 x 20in)
joanne last

This abstract study uses all the crumbling brilliance of the pastels to superimpose light over dark, dividing the picture into right-angled blocks and leaving room for us to interpret the subject matter, if there is one. An exercise like this is always worthwhile.

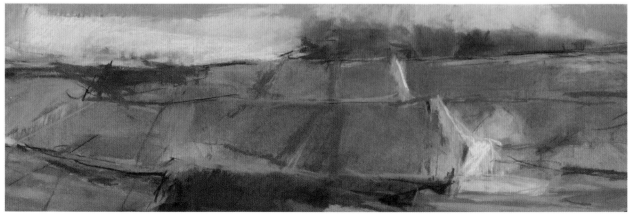

studio still life
650 x 500mm (26 x 20in)
brain gallagher

A well-composed and balanced composition with the blue-yellow combination working well and the pastels smoothly blended. Simple shapes with gentle colour contrast create the sunlit atmosphere in a room that has the feeling of a sanctuary. The blank canvas in the picture leans against the wall and the sunflower waits to be painted.

every breeze
635 x 1600mm (25 x 63in)
jeannette hayes

This large panorama of a hillside patchwork of field shapes uses large areas of freely applied colour. The folds are indicated by the receding white fences which link roofs in the foreground with the bizarre colours of the far hill and woodland. It gives its effect with great economy. We are sometimes wrong to equate slightness of technique with triviality.

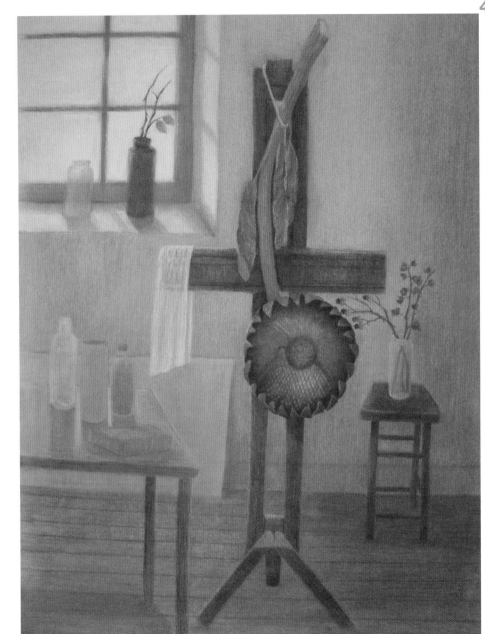

studio moor place
450 x 400mm (18 x 16in)
brian gallagher

The impact of this picture depends on the contrast between the cool, glowing interior and the warm reds of the roofs through the window. The two areas are linked by the pure orange jar on the window ledge, where all the greens are concentrated in the intensity of colour on the apples. A restrained technique and imaginative use of colour make this a romantic glimpse at reality.

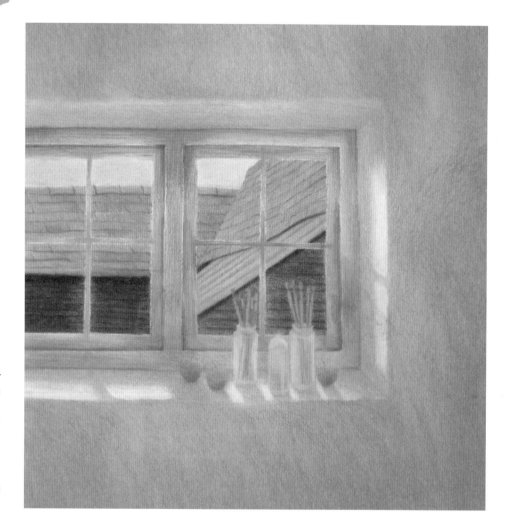

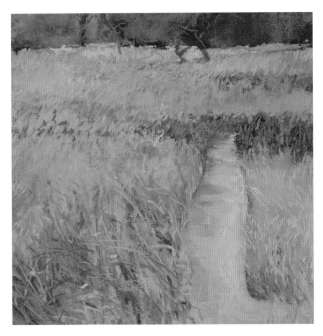

the meadow
370 × 370mm (14¹/₂ × 14¹/₂in)
averil gilkes

A tempting path through a
meadow of high waving
grasses draws our eyes
toward the profound blue on
the far edge under the trees.
The artist has adopted just
the right technique for the
plants, using many flickering
strokes to depict in the
foreground and suggest in
the distance, the rich variety
of colour in the stems
and seedheads.

liz on sofa
660 × 1065mm (26 × 42in)
bob last

Here the human form set in
an elaborate pattern of lines,
stripes and curves, becomes
part of the design and a focus
for all the colours. All the
pinks, lilacs and pale blues
give the figure a precious
mother-of-pearl tonality that,
combined with the blue of
the sheet, make one delicate
and tasteful motif. This is a
modern version of a theme
the ancient Greeks would
have recognised and admired.

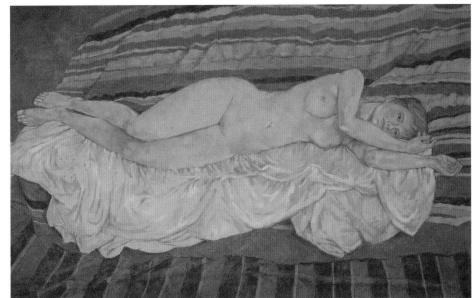

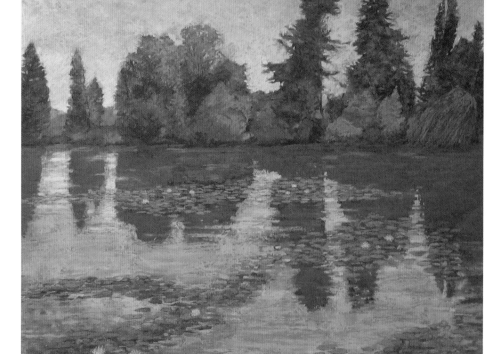

reflections
960 x 860mm (38 x 34in)
bob last

The Impressionists' subject par excellence – waterlilies on a lake reflecting a line of trees. With much adventurous colour work in the mirrored images of the trees, the frieze of trees in profile against the sky attracts the eye and the shapes seem to converge on each other.

shells and stones
225 x 225mm (9 x 9in)
brian gallagher

This is a beautifully crafted and loving study of a small section of a pebble beach, with many individual portraits of shells and eggs, the whole thing carried out within a range of cool blues and greys and achieved by much patient craftmanship.

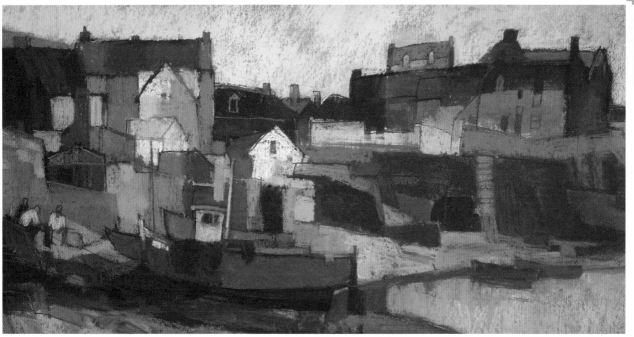

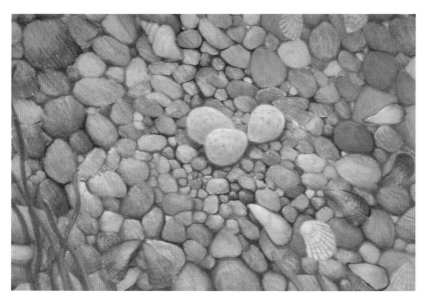

holyhead anglesey
500 x 750mm (20 x 30in)
moira huntly

At first glance, this is an attractive patchwork and a pleasant tasteful arrangement of rectangles and triangles, but on closer examination a picture in which every shape is cleverly designed to describe quite accurately every element in the scene. The key to its success is, as always, that it is based on a fine, analytical drawing.

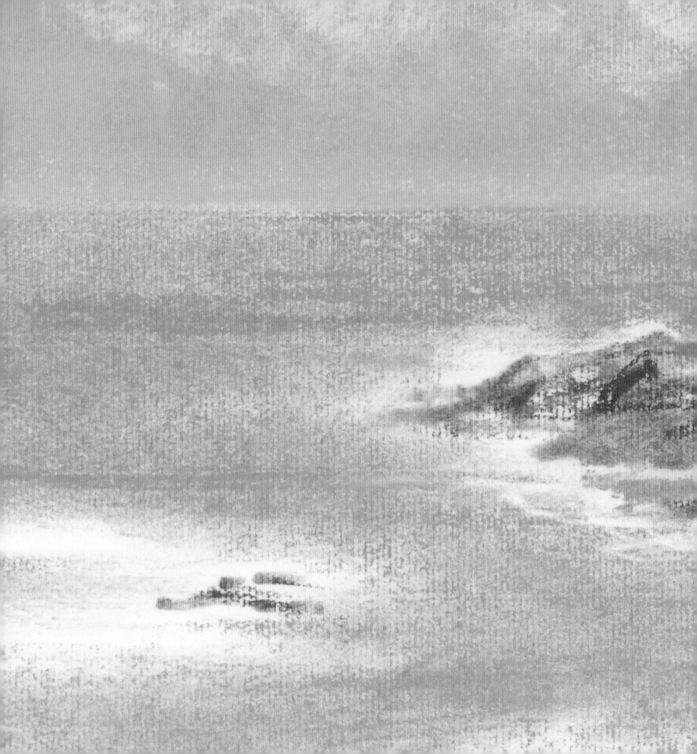

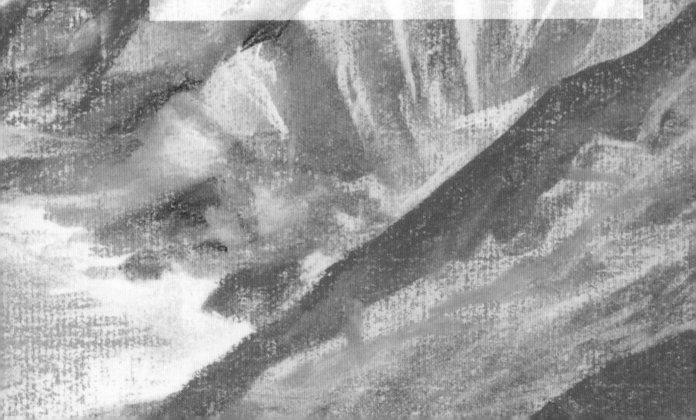

the projects

Being able to capture the essence of a scene is the skill
all artists seek to master. These projects take you step-by-step
through a wide range of different subjects, from still lifes to
distant landscapes, using a range of techniques that will help
you develop your talent as an artist.

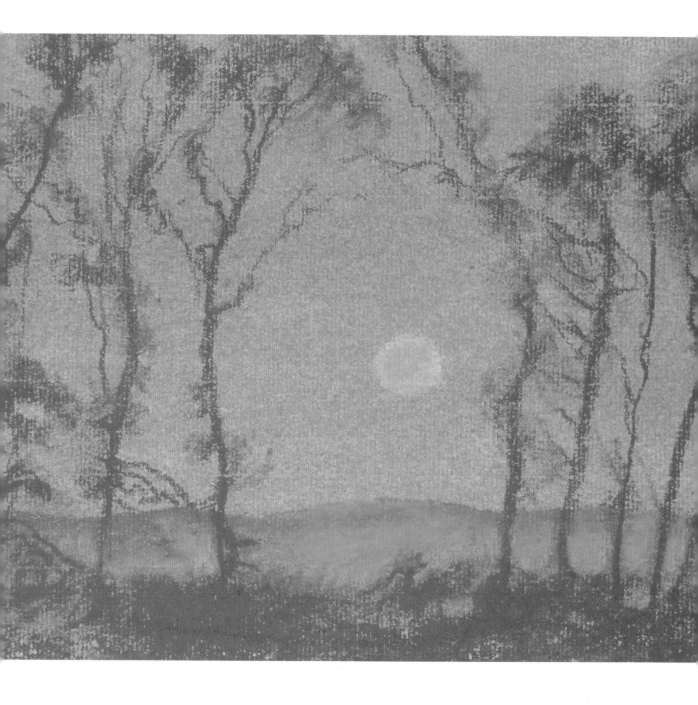

1

winter sunset

john barber

200 x 250mm (8 x 10 in)

This first project introduces you to pastels with a simple subject using several basic techniques. Aim to copy the colour scheme here, but remember there is almost no colour that cannot be found in the sky at some time and the sun can be any size. Also the thickness and solidity of the trees can vary as much as you wish. Since this project can be done fairly quickly, you could produce several versions of the sky, up to step 4 and choose the one you like best to complete the project. Trees against a sunset sky are a perennial favourite and you may be tempted to do more than one. Practice your tree drawing on the sky you liked least and you will be more relaxed drawing on a background that you value less.

TECHNIQUES FOR THE PROJECT

Lifting out colour

Colour blending

Line drawing

WHAT YOU WILL NEED

Rough surface watercolour paper
Tissue or rag
Torchons
Blutack

COLOUR MIXES

1 Payne's gray
7 Orange
10 Violet

BROAD STROKE RENDERING

Much of pastel painting depends on the accidental effects which the first strokes create. In most other media, the original and first tentative strokes are soon obliterated as the work is developed and completed. But with pastel, the power of a few strokes to suggest a cloud, a glimpse of sunlight, or a breaking wave is ever present. In many instances the first marks are so precious that it will require nothing more than a few strokes to enhance them in order to make a painting that you consider 'finished'. This will be more likely to happen if the surface being worked on is coarse because of the many small depressions that the flat edge of the crayon does not reach. So boldly

sweep your flat pastel across the paper, then stand back for a moment and think what it suggests to you. It may be something far more interesting than what you had in mind. It is this willingness to be influenced by your first mark that offers you so many more options than sticking to a pre-conceived plan. Crossing several broad sweeps of colour can suggest a line of hills, or a bank of clouds, depending on the colour. If you are able to visualise an image in the free marking of your page, then there will be others who will see it too and enjoy it. It really is worth trying – and the great master Leonardo da Vinci recommended it.

1 Use the full-length ultramarine pastel stick on its side and begin to create an area of sky. Move back and forward, to get a good covering of colour on the paper. The texture of the paper still shows through and the bands of colour overlap.

2 Next take the permanent rose and start working over the blue sky. Work in broad strokes, as you did with the ultramarine. Again, the bands of colour overlap to create areas of light and dark. The pink has modified the underlying blue.

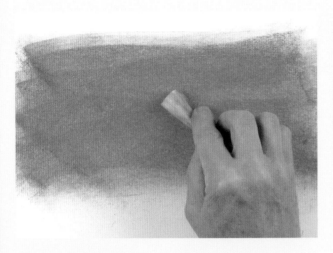

3 Take a torchon to start blending. Make sure it is clean by peeling some of the stained paper from the stick. Move this across the colour mix to blend the two colours together. Work in broad sweeps as you did with the pastels.

4 Pick up the pastel dust on the torchon and work it back into the blended colour. This will create areas of a third colour on your painting and make the colour that is there more intense. Continue to blend and modify your colours.

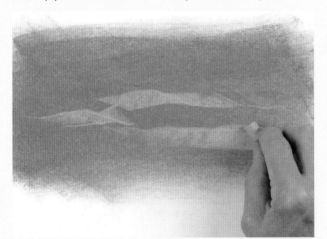

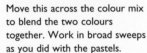

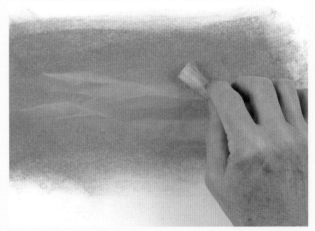

5 The torchon is now working as a tinting tool, too, since it is putting more colour (the mixed colour) back onto the paper. Now work a few lines of a paler permanent rose across the sky. These will be used to create some clouds.

6 Then take the torchon again and lightly soften these marks. Make this a softer movement with less pressure on the torchon than you applied for the previous blending. This helps to preserve the softness of the cloud shapes.

1
winter sunset

Begin by laying on colour for the background, starting with the early evening sky. Using a half-length, round, soft, orange pastel on its side, sweep colour across the paper from left to right (or vice versa if your are left-handed). Work down the paper in this way until you have covered the top third, applying even pressure as you go.

HOLDING PASTELS

When using a pastel on its side, always make sure you keep your finger and thumb on top of the pastel and not in contact with the paper. This will prevent your fingers getting in the way as you work and help you to avoid accidental smudging.

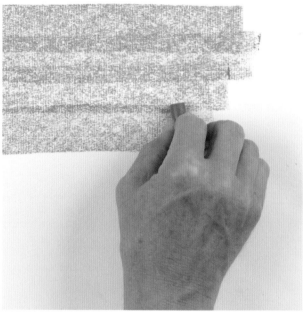

Take a light violet pastel and continue to sweep colour across and down the paper, until you reach the bottom.

RIGHT Make sure that the two colours overlap slightly where they meet and that the entire surface of the paper is covered. Finish this step by applying a lighter shade of orange over the top of the first orange layer.

STEP 1 ▶▶

STEP 2 ▶▶

Now that you have the basic colours in place, you can blend them together to create one seamless, graduated, background colour. Take a tissue or rag and work in a neat, circular motion to blend the colours. Move across the paper from left to right and top to bottom as you work and try not to apply too much pressure.

REMEMBER

When blending pastels, the idea is to move the grains of two or more colours around the paper to create a new colour. Take care not to rub the paper so hard that you remove the colour altogether, or start to damage the paper.

Draw some of the orange down into the violet, but take care not to take up too much colour on your tissue or rag.

RIGHT Blend the violet down until it almost disappears. Use your rag in a dabbing motion to lift colour off.

STEP 3 ▶▶

STEP 4 ▶▶

1
winter sunset

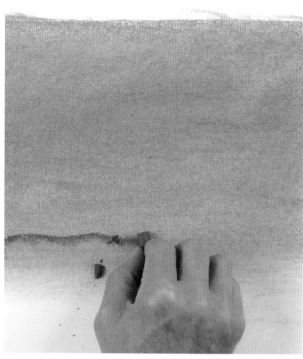

RIGHT Holding a torchon in the middle for best control, blend the blue of the distant hills. Press the grains of the pastel into the paper so that the texture disappears. Keep the pressure light to avoid removing colour as you work.

Decide where the sun is going to be and, using a piece of tack, work in a circular motion until you have a clear, round area devoid of any colour.

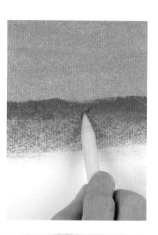

Take a pastel that has a slightly more blue shade of violet to draw the outline of the distant hills. Keep your finger and thumb on the top of the pastel's rounded surface and the tip of the pastel firmly on the paper. If the pastel breaks do not stop – this would make you lose your drawing edge – but simply blow loose bits away and continue.

RIGHT Use the pastel on its side to apply even colour below your drawn outline of the hills.

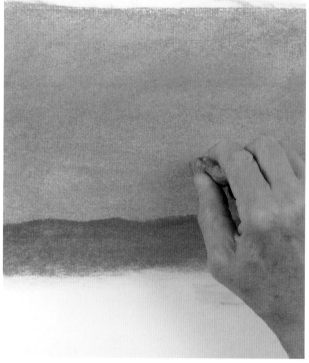

STEP 5 ▶▶

STEP 6 ▶▶

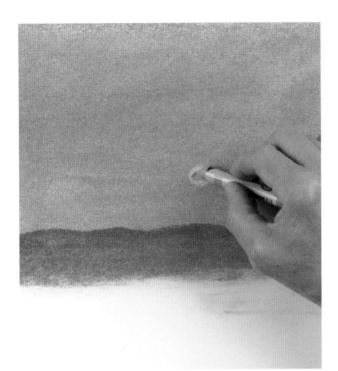

RIGHT With the background now complete, you can start to build up the foreground. Use the Payne's gray pastel for the trees. Careful drawing is required here. Push the colour into the sky, with just the tip of the pastel resting on the paper.

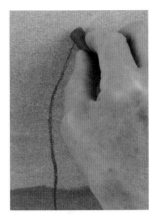

Draw the trunks first. You can add branches and foliage once you are happy with how the overall composition is shaping up.

Apply a very light orange colour to the sun. Use just the corner of a full stick and precise movements to fill the space that you have made. Use the torchon to expand the colour carefully, filling the whole disc.

REMEMBER

A torchon will pick up grains of colour as you use it, so make sure it is clean before working on areas of light or bright colour. Either sharpen it using a craft knife or pencil sharpener, or take a new torchon each time.

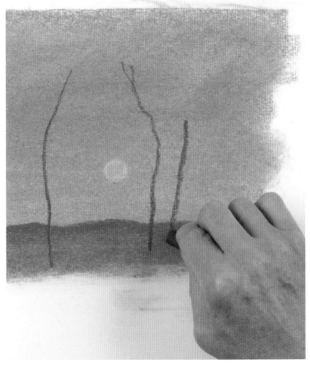

STEP 7 ▸▸

STEP 8 ▸▸

1
winter sunset

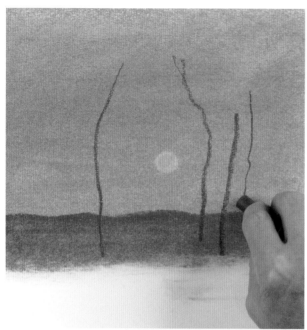

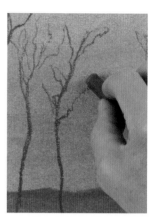

RIGHT Do not worry if your lines do not join up at this stage: quite often you cannot see whole branches in nature.

Make one or two bolder strokes, delicately framing the setting sun with the outlines of your trees. At the bottom of the paper, the tree trunks disappear into the violet landscape.

Use your own discretion as to how many trees make an interesting group. Take care not to have them all positioned the same distance apart.

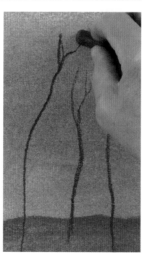

RIGHT Start to add some of the branches now, still using the tip of the pastel. The trees against the sunset are reminiscent of Japanese painting.

STEP 9 ▶▶

STEP 10 ▶▶

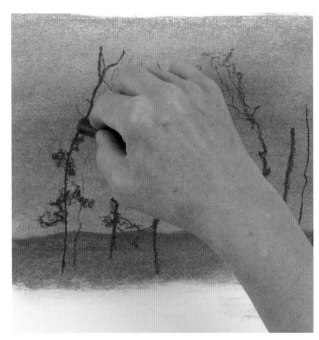

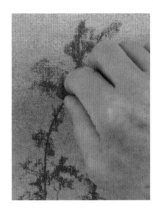

RIGHT Continue to build up the foliage using the side of the pastel and making small, deliberate marks.

Consider the shapes of your trees as you work. Blending some of the foliage colour into the sky will give the trees greater depth, blurring the distinction between sky and foliage.

Now use the side of the Payne's gray pastel to add foliage to the branches of your trees. Work from left to right and make the most of the medium's expressive qualities to achieve soft nuances of colour.

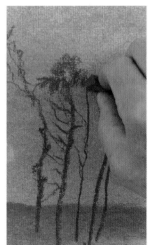

RIGHT The texture of the paper will come back into play at this stage, giving the impression of sky seen between the leaves.

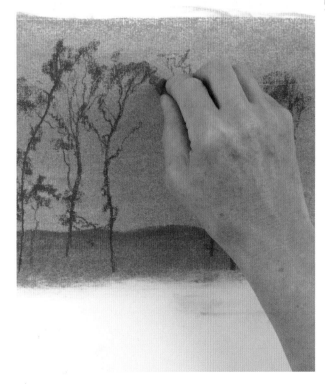

STEP 11 ▶▶

STEP 12 ▶▶

winter sunset

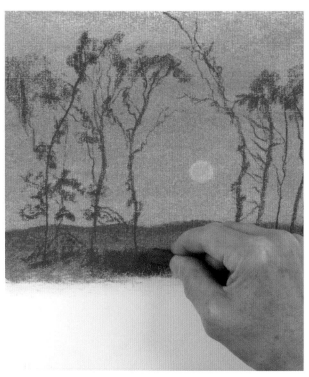

Use the torchon to solidify and soften the edges of the foliage slightly, so rendering the haze that often accompanies such a beautiful sunset. Make sure, at this stage, that all of the areas of foliage are visibly attached to the branches of the trees.

A DRAWING TOOL

You can also use the torchon as a drawing tool. As you work with it, the torchon picks up colour, which you can then use to draw on somewhere else in the picture, adding finer detail if you wish.

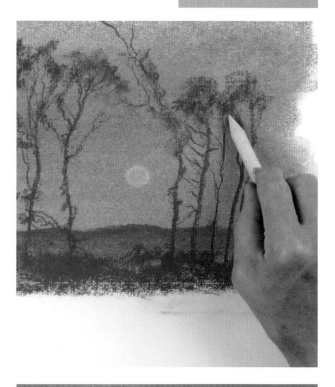

Once the trees are complete, you can continue to work on the foreground. Use the Payne's gray to darken the area at the base of the trees, obscuring their roots.

RIGHT Work with the pastel on its side, applying pressure evenly over the paper. If you prefer to leave the texture of the paper coming through here, then do so. If not, use the torchon to make the colour more solid.

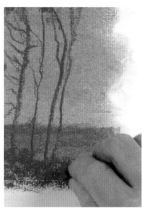

STEP 13 ▶▶

STEP 14 ▶▶

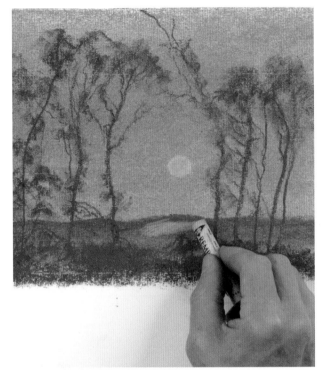

Stand back from your picture to see whether any areas need more attention and blend any final details using the torchon.

PAPER TEXTURE

The paper used for this project is machine made and has parallel lines in places, which can become prominent when you apply the pastel (see left). If you do not want these lines to show, you can blend them out using a torchon.

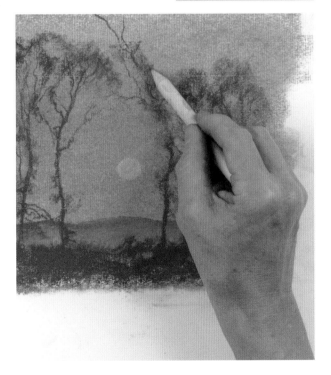

The hills in the distance now look too purple. Without going into the sky, work over the original colour using a paler violet. This will be fiddly in places, since you have now worked on the trees.

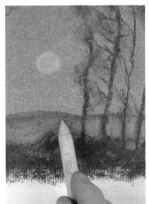

RIGHT With the torchon, blend this paler violet, in order to achieve a more solid colour.

STEP 15 ▶▶

STEP 16

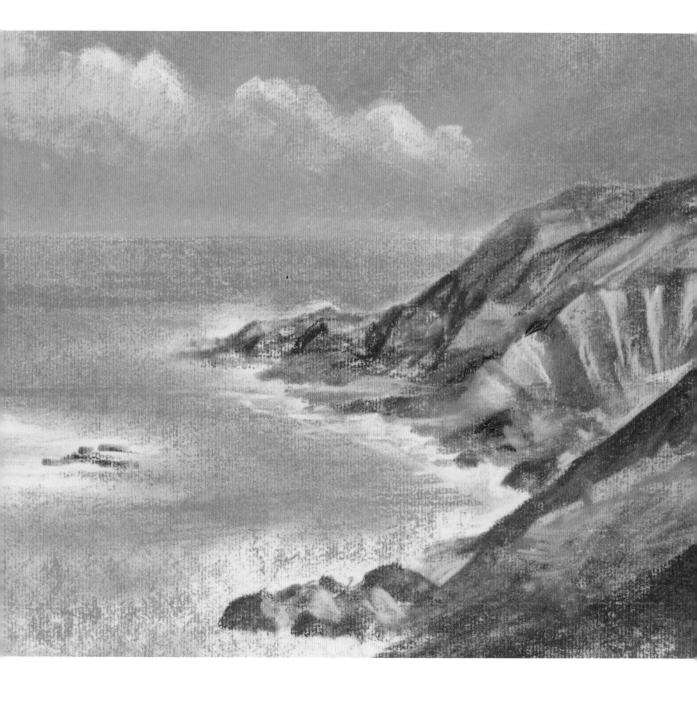

2

cliffs in sunlight

john barber
250 x 200mm (10 x 8in)

Cliffs, rocks and sky are good subjects for trying out many kinds of textures and shapes, from smooth blending in the sky and clouds to broad strokes made with the edge of the pastel sweeping across the picture and revealing the grain of the paper, broken up by smaller marks, building the illusion of sunlit rocks. Light in nature is always changing. If you paint outdoors (and pastel is used for both painting and drawing), you will soon find how often you have to adjust your contrasts. Go out with a box of pastels and a small pad of paper to look at nature and interpret it in your own way. With the skills you have learned from the projects, you will realise how quick and easy pastel sketching can be.

TECHNIQUES FOR THE PROJECT

Whole-pastel painting

Using paper texture

WHAT YOU WILL NEED

Rough surface watercolour paper
Torchons
Tissue or rag

COLOUR MIXES

1 Payne's gray
2 Viridian
4 Yellow ochre
7 Orange
10 Violet
11 Cobalt blue

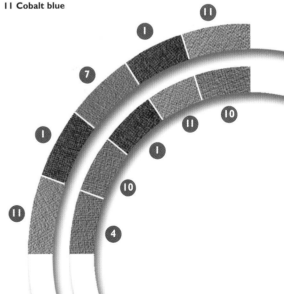

USING THE PASTEL AS A DRAWING TOOL

Pastel is as much a drawing as a painting medium. The way that the marks are made gives a distinct graphic definition. This can be preserved as a stylistic decision so that you may decide to lay your marks one upon the other like tiles until the image becomes recognisable. Just as many oil painters use wide flat brushes to make square marks side by side to achieve a distinctive style, so you can restrict yourself to pieces of pastel of the same length to give a consistency to your work. Limiting yourself to one colour at first and drawing the complete scene in lines is another approach which works well and can be carried out in any colour. Any area of colouring in pastel can be treated in a graphic, rather than a painterly, way. By painterly in this context, we mean working in solid colours, blended into each other. Graphic treatment will involve many parallel lines of different colours, placed close together to give the illusion of a single colour. Lines will make the surface of the painting and the colour, because unblended, looks brighter. With this style, the coloured lines can still be used by their change of direction to model the form. Always remember the shape under the colour. Degas, in his later work, gives us a better insight into his methods because his marks got bigger and more free. His pastels were always another aspect of his obsessive desire to draw.

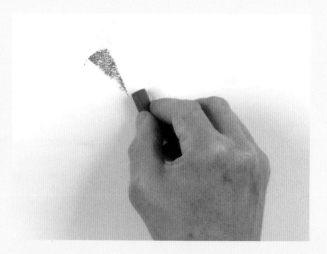

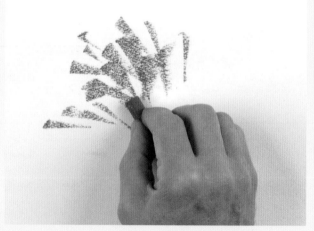

1 Holding the length of the pastel between your finger and thumb, put your finger and thumb on the paper and twist the pastel through around 30 degrees to get a wedge-shaped mark. Repeat this several times on your paper.

2 This enables you to create similar shapes. Keep the end of the pastel twisting slightly as it touches the paper. However slight the movement you will get a coloured shape on the paper with one small twist of your finger and thumb.

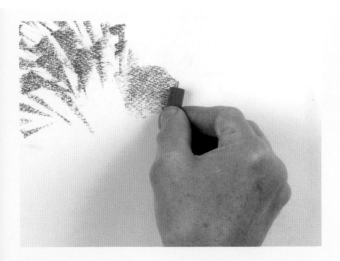

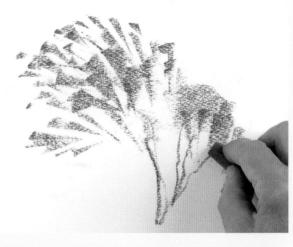

3 These marks can be superimposed one on another, rather than all being worked side by side. This helps you to build up light and darker marks. Keep some light and sketchy and make others stronger in colour.

4 Lift the pastel and use the edge to do some linear work. Look at the marks you have made and see if they suggest a form to you. If they do, then work on them some more. Here the shapes suggest a plant or tree.

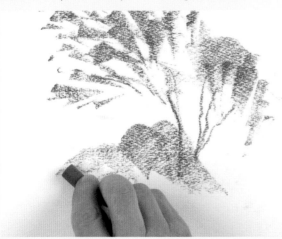

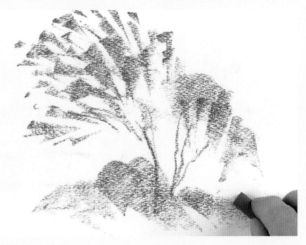

5 Then use the pastel on its side and pull it lightly across the paper to create a sense of the ground, anchoring the tree in space. Pull the side of the pastel to give an area of solid, pale tone as you build up your little sketch.

6 This simple study needs no further elaboration. It demonstrates three different ways of holding your pastel and manipulating it to make marks: twisting on the paper for wedge shapes, on its edge for lines and on its side for the ground.

This project is about the definite shapes of the rocks and the indefinite shapes of the water. Use a pale violet pastel to sketch the main lines very lightly. Remove the paper from the cobalt blue pastel and break the stick into a usable size for working on its side. Lay down colour for the sky: a good-quality, textured paper will take up a lot of colour, which you can then rub in with the torchon to achieve an intense blue.

TRICK OF THE TRADE

A clever way of drawing the horizon is to place a piece of paper across your drawing paper and run a pastel, on its side, across the edge. Working in this way means that there is no dark line where the sky meets the sea.

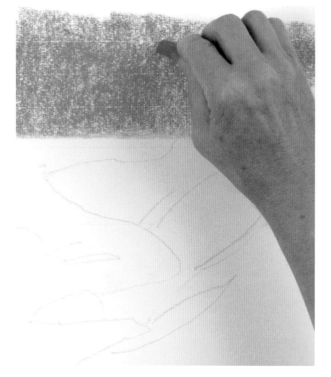

Use a pastel from the viridian range for the sea. Notice how this colour now lends the sky a more lilac hue. The two colours harmonise well.

RIGHT Fold a tissue or rag into a smooth ball and intensify the colour of both sky and sea by rubbing grains of pastel into the white specks of paper. By working from left to right on the sea, you should also be able to create an impression of movement.

STEP 1 ▶▶

STEP 2 ▶▶

Once you have the basic sea and sky colours in place, you can begin to work in greater detail. Start by rubbing some paler blue into the sky. This pastel has more white in it and helps to convey the slightly patchy nature of a summer sky.

USING TEXTURE

The texture of the paper you choose will affect your pastel marks, as will whatever surface lies underneath your paper. You might choose to experiment with different textures – woodgrain for a woodland scene, for example – in order to add another dimension to your pastel work.

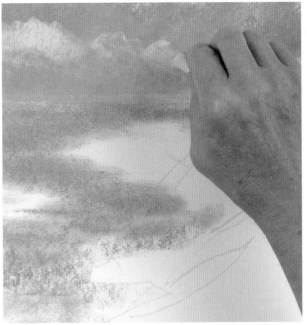

Now take a pale Payne's gray pastel and rub some of this into the sky area to indicate clouds.

RIGHT You can then use the pure white pastel to highlight the edges of the clouds, so giving them more depth.

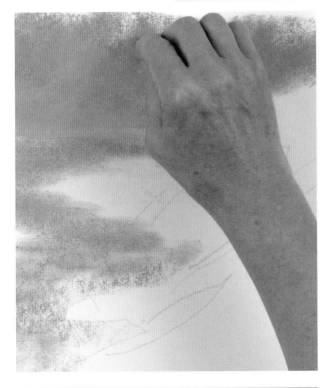

STEP 3 ▶▶

STEP 4 ▶▶

2
cliffs in sunlight

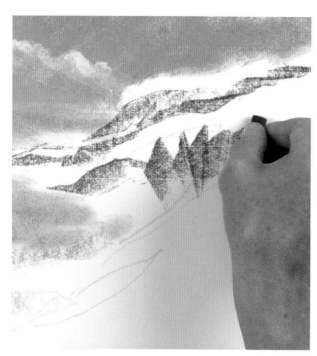

RIGHT Once you have established the shadow areas you can start to add some warmer colours to the landscape, starting with orange.

Establish outcrops of grass and moss on the cliffs, using a pastel from the viridian range.

Use a light-toned Payne's gray to indicate the rhythm of the rocks and how they are cast into light and shade. Slide and twist the pastel on its side to create the random shapes of the crags.

RIGHT Leave some of the texture of the paper showing at this stage, to help define areas of light and shadow. Notice how the the rocks also cast shadow into the sea.

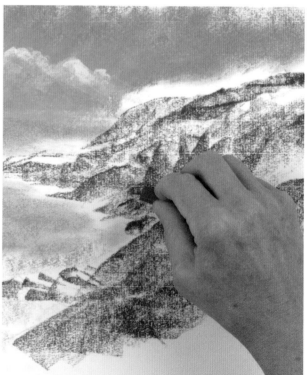

STEP 5 ▶▶

STEP 6 ▶▶

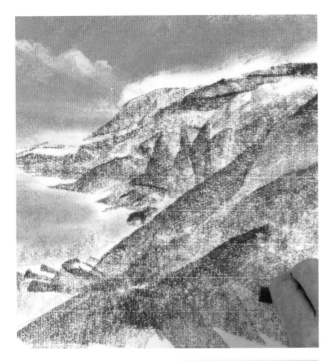

RIGHT You have now laid down the basic areas of colour, so you can start to blend your pastels. You may find that blending with your fingers gives the best results, or you could use a torchon if you prefer.

Intensify the warmer orange and green colours by blending with a torchon. This also helps them to merge in places with the grey of the rocks.

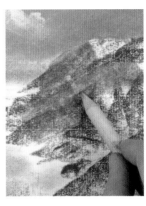

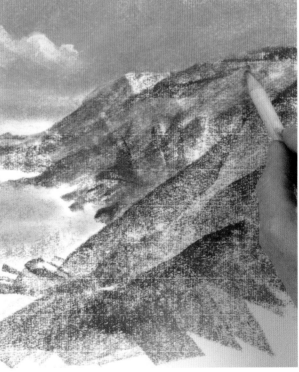

Turn the pastel on its side and blend the green into the grey cliffs in some areas.

RIGHT Now turn your attention to the profile of the rocks, rubbing in a little more blue where necessary, to achieve a more pleasing shape.

STEP 7 ▶▶

STEP 8 ▶▶

2
cliffs in sunlight

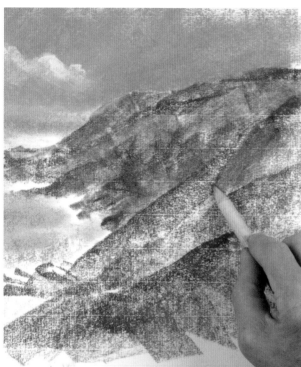

RIGHT At this stage, you can decide whether to leave the picture as a light, lively sketch in which the texture and colour of the paper play the main part, or to work the colours in and overlay them with lighter tones, as will be done here.

Start by adding some yellow ochre to give an indication of the beach and blend the colour in using the torchon. Use a clean torchon to blend the sea in the area where it meets the rocks.

Notice how the colours change as you blend them, resulting in a range of colours and tones that give far greater definition to the landscape as a whole.

RIGHT The torchon will pick up pigment as you can work. Use this to add colour to any white areas that remain in the rock and on the little rocks in the sea.

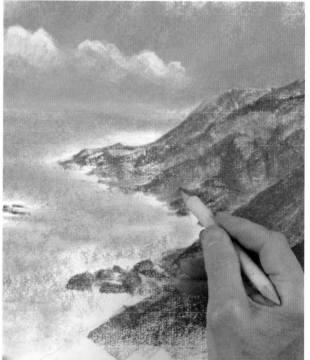

STEP 9 ▶▶

STEP 10 ▶▶

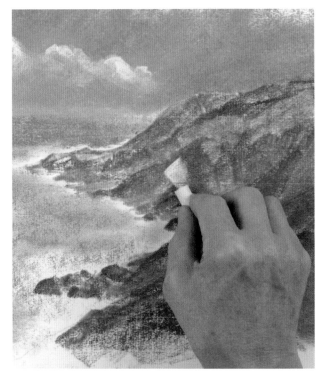

RIGHT Create dramatic sweeps of light on the rocks, using the pastel on its side. Work around the cliffs, picking out those areas that are the lightest

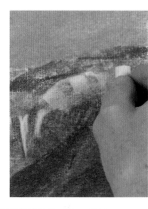

Concentrate on the larger areas first, then start making finer marks for areas that require greater detail.

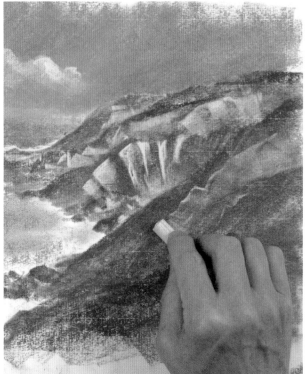

Now start to get back some of the lights that you may have lost during blending. In some places the texture of the paper still shows through, while in others the colours are more solid.

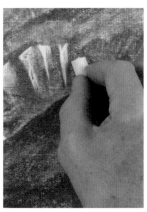

RIGHT Use some of the pastels with more white in them. Take the light grey that you used for the clouds in step 4 and use this in the light areas of the rocks.

STEP 11 ▶▶

STEP 12 ▶▶

2
cliffs in sunlight

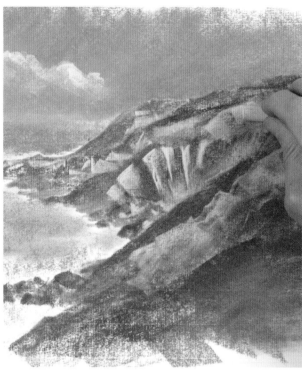

Now you can return to the darker areas of the picture. Work some blue into the shadows of the cliffs. to give the impression that the sea is being reflected up onto the rocks.

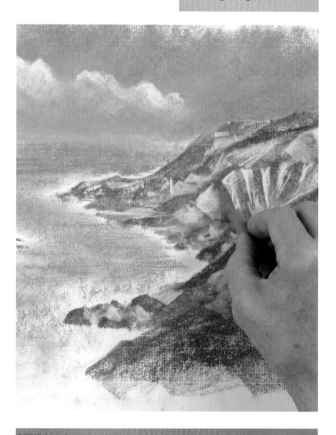

Continue to build up areas of light on the rocks before progressing to work on the sea. Add more light grey until you are satisfied with the colour.

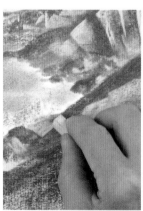

RIGHT Use the tip of the pastel and a feathering technique, to work more definition into the sea where it meets the rocks.

STEP 13 ▸▸

STEP 14 ▸▸

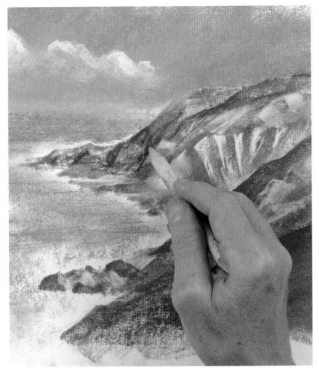

Stand back from your work to consider the drawing as a whole and carry out any final blending with the torchon. Use the white pastel to add a few highlights around the sea edge, but avoid areas where the texture and colour of the paper are still showing through, as the white pastel is a different colour from the white paper.

FIX IT

You can use a fixative spray to stick powdery pastels to your support and spray as often as you wish. At first it will darken the colour but as it dries the colour will return, although not quite as bright and sparkling as before. Work over the picture again to regain crispness of colour and do not spray the final touches.

Using the Payne's gray pastel, add some deeper shading to the rock faces that are in shadow. You can use the torchon, if you prefer, to work some of the colour deeper into the crevasses.

RIGHT Blend the dark grey back with the torchon if it begins to look too stark.

STEP 15 ▶▶

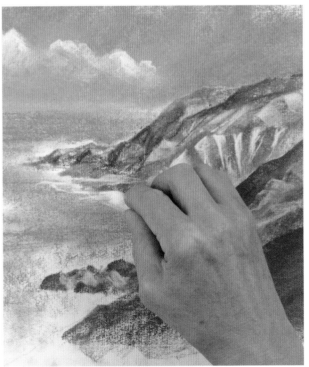

STEP 16

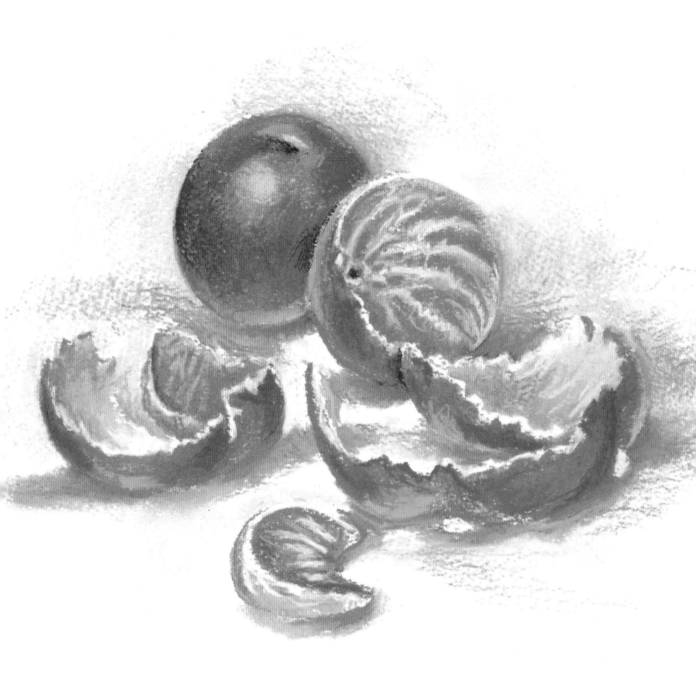

3
clementines still life
john barber
250 x 300mm (10 x 12in)

Glossy fruits, curling peel, interlocking curving lines and flowing cast shadows give subject matter that is easily available in any kitchen. Take something that catches your eye from the fruit bowl or vegetable rack. The combinations of colour, texture and shape in endless variety are ready for you to paint. Do not spend too long on the arrangement but do look at your objects from different angles before you decide your viewpoint. This will help to improve your sense of composition and will tell you what you like to paint. Knowing this is the first step to becoming aware that you are a unique artist, however hesitant you may be at present. This is a simple subject for relaxed and free handling of the pastel medium.

TECHNIQUES FOR THE PROJECT

Drawing with a pastel edge

Adding highlights

WHAT YOU WILL NEED

Rough surface watercolour paper
Torchons
Blutack

COLOUR MIXES

3 **Burnt sienna**
4 **Yellow ochre**
6 **Cadmium yellow**
7 **Orange**
8 **Cadmium red**
10 **Violet**

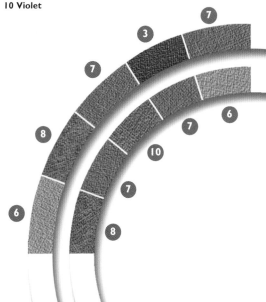

CREATING HIGHLIGHTS AND SHADOWS

Highlights and shadows are the dramatic opposites between which every tone from white to black has its place on a reducing scale of brightness. We see things as degrees of light and shade. This is the way we recognise objects in space. Colour does not give us this information. If you look at a very small, black-and-white photograph in which the heads are less than 10mm (½ in) high, you would still recognise a face, from the shape of five or six tiny cast shadows. This demonstrates how very good our eyes are at measuring shapes and our brains at storing information. In painting, it is rare for any contrast to be as extreme as black and white. Even in the most dramatic lighting of the Old Masters, their shadows are

not really black. Although they were exploiting all the modelling of forms in light, their highlights, when pure white, are quite tiny, but always in exactly the right place. Study the exercise here to understand how simple this principle is. Studied carefully, it will give you a better understanding of what you see and can be the key to helping you to paint it. The study of clementines deals mainly with the colour variations we can see, but underlying it is an awareness of the shadow shapes that give us clues to the third dimension of the fruits. Imagine that all the oranges are greys or make a black-and-white photocopy to help your understanding of this principle.

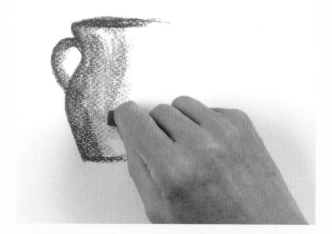

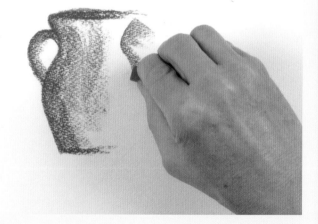

1 Use a deep burnt sienna pastel to create the basic shape of a jug. Use the pastel on its side full strength to create the left-hand area of the jug where the colour is at its strongest. Then use a lighter touch to create the central area.

2 Take a cobalt blue pastel and use it on its side to create a shadow on the right-hand side. This stroke of colour will complete the basic silhouette. The study is now clearly a jug and this can now be built up and anchored onto a table top.

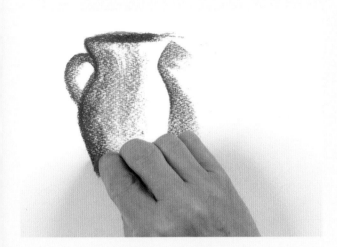

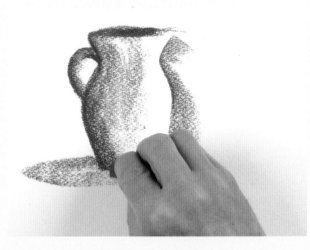

3 Leaving an area of pure red, lay the blue on top of the red to create the shadow on the left-hand side of the jug. There is also a stripe of pure blue on the extreme left of the jug where there is no light falling at all. Scrub this in more strongly.

4 Take the same colour to create the area of shadow on the left of the jug. This is softer than the shadow on the jug itself and has no red in it. Use a delicate touch to feather the edges of the shadow up to the edge of the jug.

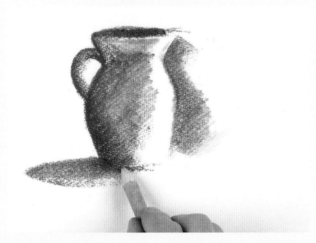

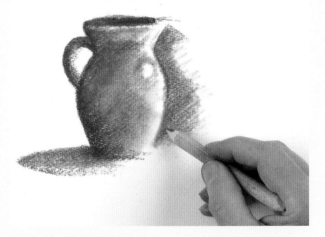

5 Take a torchon to blend the two colours. At the moment the paper is being used as the highlight 'colour'. Blend using the torchon. Drag the shadow colour out with the torchon. The shadow and the colour of the jug are now combined on the paper.

6 Now take the torchon and look to see where the highlights would be. Use the torchon to blend the edge of the pale red into the white paper. Define the highlight in the centre. Note that the torchon is acting as a drawing tool here.

3
clementines still life

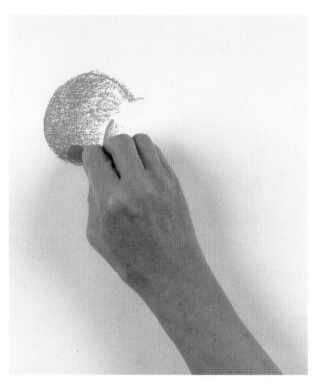

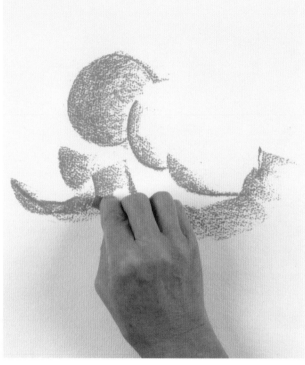

Start by drawing the skin side of the partially peeled orange and then draw and fill in the shape of the whole orange to its left. Take time to get the shapes right at this early stage. Using the side of the pastel, make bold strokes to capture the basic curves. The shape of the pastel itself will dictate this to some extent.

REMEMBER

The texture of the paper is important for this project, particularly once you start to blend the pastels, as there may be areas that benefit from the texture showing through. Think about the final effect you are looking for and avoid blending over every area uniformly, as this would flatten the colour.

STEP 1 ▶▶

Draw in the discarded peel of the second orange and the single segment in the foreground using a little less colour.

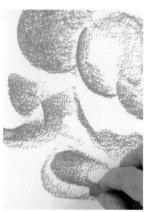

RIGHT Now turn to the lighter areas of the fruits. Starting with the yellow-orange edge of the fruit segment, work lightly with cadmium yellow to make a solid colour, but leave the texture of the paper showing through. Use the same yellow to lay colour over the lighter areas of the whole and peeled oranges.

STEP 2 ▶▶

RIGHT Using a clean torchon and working from the top of your drawing, make small, circular movements to blend the colours. Press the pastel grains into the depressions of the paper in those areas where you want to create solid colour.

Do not be afraid to leave the texture of the paper showing through in places, however – along the edge of the peel, for example – to help render the illusion of roundness.

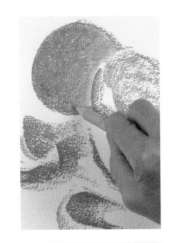

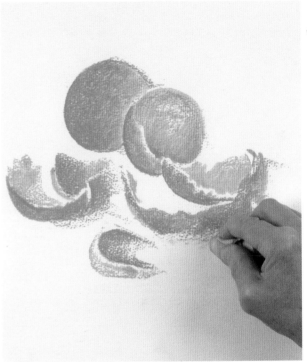

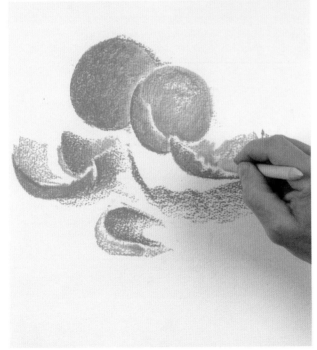

Continue to lay down and blend colour, strengthening the tone of the fruit and using the torchon to refine the shapes. Now take a clean piece of tack and start to lift out some of the pastel that you do not want, refining the shapes of the fruit still further.

USING A TORCHON

A torchon picks up colour as you work and may deposit pigment where it is not wanted. Start work on a new drawing with a clean torchon, sharpened using a craft knife to remove previous colour. Shape it into a neat point or a chisel-type edge depending on what suits your work.

STEP 3 ▶▶

STEP 4 ▶▶

clementines still life

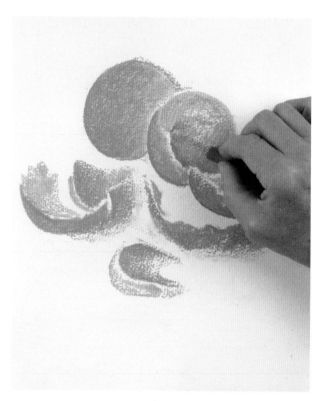

Now rub a deeper orange into parts of the peel. Use a square-section pastel for this and apply slightly more pressure, bringing up the texture of the paper again. Take a paler tone of burnt sienna – one with a lot of white in it – and modify the colour inside the discarded peel so that it is not too chalky and pale.

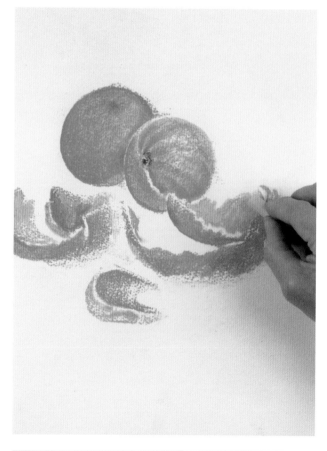

Start to work on some of the darker tones. Use a medium-strength burnt sienna to define the segments of the peeled orange. Follow the shape of the fruit, emphasising its roundness.

RIGHT Use the same pastel to model the form of the whole orange, adding the depression on top, which contributes to its overall shape. Use the torchon to blend the colours here.

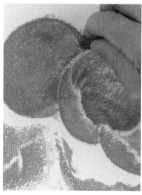

RIGHT In some places you will need to blend your colours with the torchon, while in others, it is enough to feather colour into your drawing as you go.

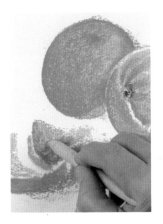

To make a setting for the composition, look at where and how the shadows fall. Take a pale violet pastel and lay down colour in those areas in which a shadow will help the overall composition.

Work around and under the partially peeled orange. Bring shadows up to the fruits to refine their shapes. In other areas – for example, on the discarded peel – take the shadow colour into the fruit to blur the edges. If you take the violet into the fruit, you will get a slightly different colour. This is not a problem, however, as shadows often contain hints of the colours of the objects that are casting them.

PAPER TEXTURE

The torchon is not used on any of the background colours. Instead, the lovely texture of the watercolour paper is left showing through and contributes a great deal to the liveliness of the picture.

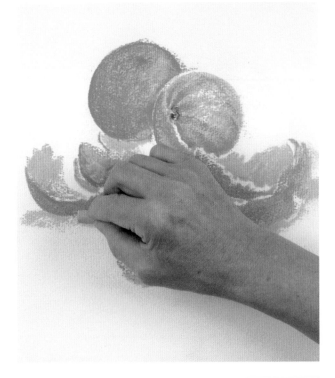

STEP 7 ▶▶

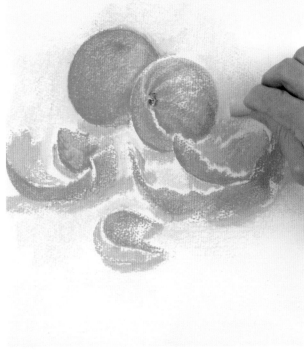

STEP 8 ▶▶

3
clementines still life

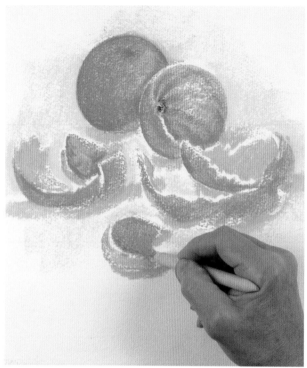

RIGHT Darken some of the shadows using a slightly stronger tone of violet. Do not obliterate the lighter shadows, just mark those areas where the shadows are deeper – typically those closest to the form – and use the torchon to blend the colours into one another.

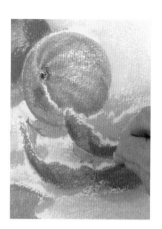

Use a yellow ochre pastel to render the shadows on the fruit.

Return to the fruit. Use the torchon to eliminate any texture that remains on the single segment in the foreground.

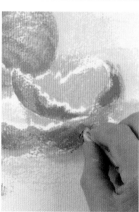

RIGHT Elsewhere, use a stronger orange to intensify the colour in areas where torchon work has reduced their strength.

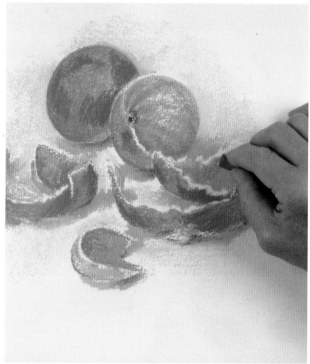

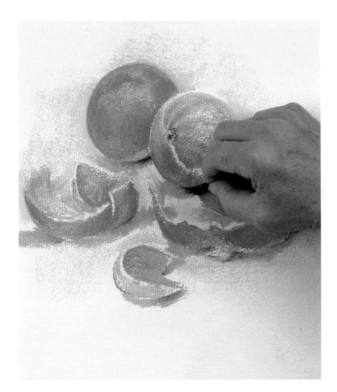

Now draw in the ribs on the peeled fruit, rubbing in some half-strength burnt sienna, then add some orange. This will bring up the lights on the fruit. Blend using the torchon and add a little white pastel to pick out the pith.

BE CONFIDENT

This study should not be too detailed and should not be overworked. Instead, the movement and texture in the watercolour paper should provide the drama. Have the confidence to know when to stop.

Use a sparing amount of black pastel to define the very darkest areas of shadows.

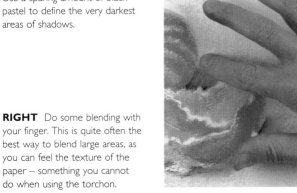

RIGHT Do some blending with your finger. This is quite often the best way to blend large areas, as you can feel the texture of the paper – something you cannot do when using the torchon.

STEP 11 ▸▸

STEP 12 ▸▸

3
clementines still life

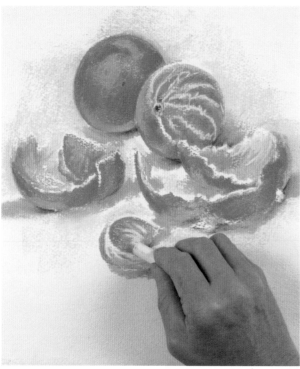

You need to apply a bit of pressure to draw over darker colours. When you feather the white into the edge of your existing colours, it blends without needing the torchon. Create some modelling on the dark side of the orange and at the top. Blend this in lightly with the torchon. Here you are softening, rather than pure blending.

Create highlights using a very deep cadmium yellow. This should create a glow in certain areas. Work some of the yellow into the texture of the paper. Use a white pastel to draw in some details. These may look crude to start with, but will be blended to create areas of sparkle.

RIGHT Use the white pastel for highlights and also to blend into other colours to create the lighter tones in the fruit.

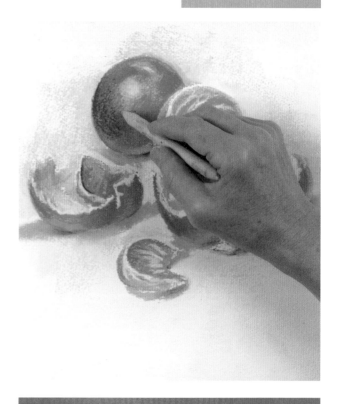

STEP 13 ▸▸

STEP 14 ▸▸

RIGHT Work a darker edge to the whole fruit using a dark tint of cadmium red and blend using the torchon.

Define some of your edges using a light burnt sienna pastel as a drawing tool. This starts to give the slight illusion of the third dimension. Working this colour into yellow gives an orange glow.

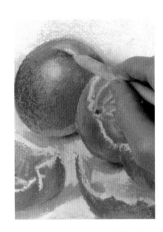

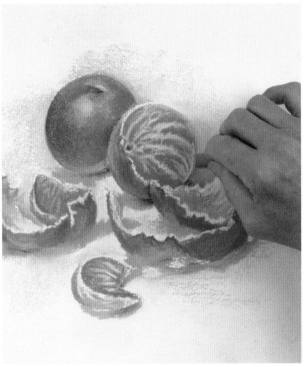

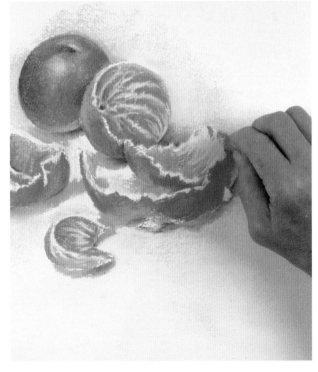

Finally, return to the shadows. In this instance they look as if they need to be deeper, so take the violet pastel and sharpen them a little. This will also help to accent the edges of the fruit and clean up the lines of their forms.

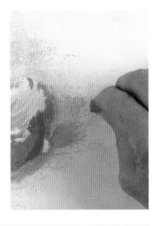

RIGHT Feather colour across the paper to keep the texture showing. This makes for a more painterly effect.

STEP 15 ▶▶

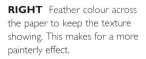

STEP 16

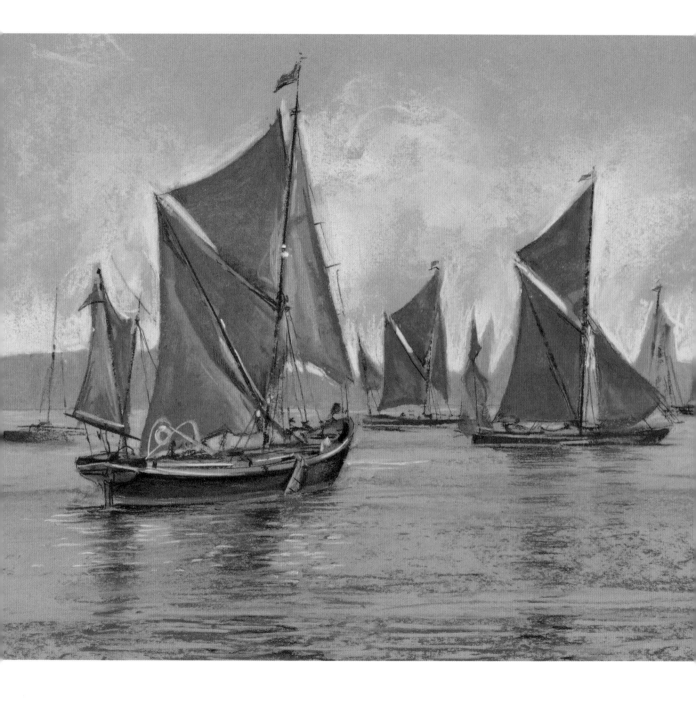

4

thames barge race

john barber
250 x 300mm (10 x 12 in)

The subject here is sails against sea and sky, with reflections seeming to go deep into the water. These geometric shapes of dark, rust-coloured sails make patterns against a light sky. The theme of barges at the annual race has been explored by many artists and the flexibility of composition and its simple colour scheme explain its popularity. The barges are arranged on a flat surface, so the sizes can be varied to make a satisfying composition. Painting the boats in profile keeps the drawing element simple and minor changes in the sails add variety. Painting several boats sideways gives a repetition of shapes and the addition of smaller and paler versions of the same shapes adds distance in the picture.

TECHNIQUES FOR THE PROJECT

Blending

Pastel edge drawing

Parallel line work

WHAT YOU WILL NEED

Buff-coloured smooth illustration board
Charcoal pencil
Torchons
Cottonbuds
Putty rubber

COLOUR MIXES

1 **Payne's gray**
3 **Burnt sienna**
4 **Yellow ochre**
8 **Cadmium red**
10 **Violet**
11 **Cobalt blue**

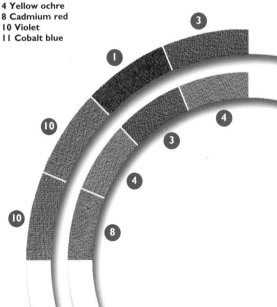

USING A TINTED GROUND

Working on a tinted ground is an option that painters take in order to arrive more quickly at a finished result, especially if they are aiming at a fully modelled scheme of light and shade. The Impressionists of the 19th century abandoned this practice because they were rejecting tradition and aiming to create works using only the primary colours, which would have been dulled by a tinted ground. But for centuries before them, going right back before the Christian era, all decorators and painters had relied on a tinted middle tone on which to draw their designs and then work toward the stronger darks and lights. To obtain the correct tonal balance when working

on a tinted ground, it is vitally important to know what is the lightest and what is the darkest area in our picture. You can choose to work from either end of the light scale. One way to establish this in any subject for a picture is to half close your eyes. The last thing you can see as you close them is the lightest feature. You can also do this by looking through several pairs of sunglasses. As you can see from the first picture below, the lightest object, even as a flat shape, will soon establish what the subject of a painting is. As soon as the left-hand shape was laid in, the building in perspective is recognisable. If it were drawn more carefully nothing further would be needed.

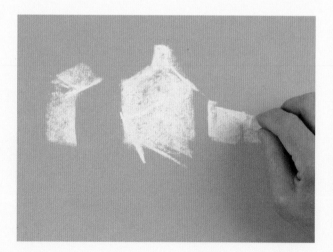

1 Use a pale yellow ochre pastel on its side to create approximate shapes of the walls of a cottage. Use the colour of your illustration board as your shadow 'colour'. Define the edge of the second cottage in the same way.

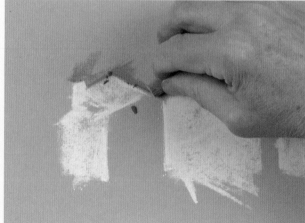

2 Then take the ultramarine pastel and start to indicate the sky, working around the rooflines, defining and re-drawing their shapes. Use the pastel on its side to create an area of solid colour, around all the buildings and tidy their edges.

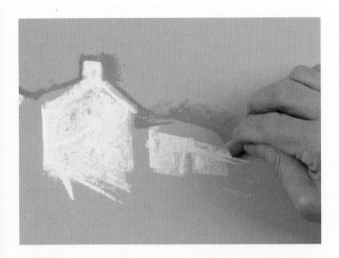

3 Once you have drawn around the basic shapes, use the pastel on its side to create more sky. Then add touches of pale permanent rose to make the sky more interesting. None of the colours are blended in this study so far.

4 The pink is also defining the edges of the blue, to create the illusion of hills in the background. This is the same technique: using the pastel to define forms, in this case first the cottages, then the hills, that are different from the sky.

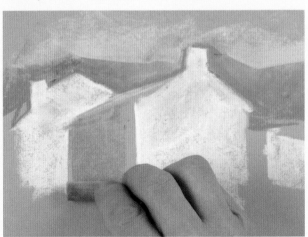

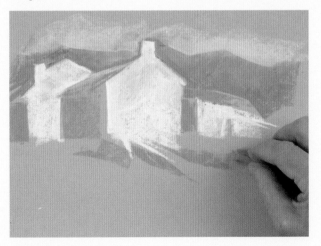

5 Take a pale tint of Payne's gray and use this on the cottages to indicate their fronts, which are in shadow: the light in this sketch is falling from the top right onto the ends of the buildings, so their fronts are in shadow.

6 Using the same tint of Payne's gray, start to indicate the ground. This anchors the cottages in space, with the sky above and the ground beneath. This whole study is worked in only four colours and with no colour blending.

4
thames barge race

The subject here is the pattern of the sails against a very pale sky and their reflections in the water. Sketch in the main lines very lightly using a charcoal pencil. Do not worry about anything other than the shapes in relation to each other. Establish the horizon behind and between the boats, using a blue-toned Payne's gray pastel. Note that there are one or two slight variations of tone in the horizon.

REMEMBER

A charcoal pencil is simply compressed charcoal in a wooden casing. Unlike graphite, it has no shine. When you lay pastel down on top, the pigment blends with the charcoal. This is not a problem as the drawing lines can be looked at and redefined if necessary at a later stage.

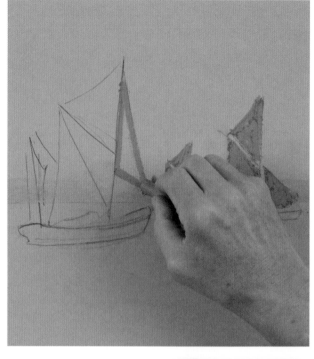

Use a light tone of burnt sienna to establish the shapes of the sails. These will vary in intensity depending on how far away they are. Put some colour on all the sails initially.

RIGHT You now have the combination of three colours: the buff of the paper, the reddish sails and the grey of the land on the horizon. Smooth this out a little with your finger. The pastel works almost as a wash owing to the smoothness of the board.

STEP 1 ▸▸

STEP 2 ▸▸

Begin to add tone to the sails so that they range from dull in the distance to bright in the foreground. Apply a darkish burnt sienna over the distant sails. This will obscure the orange for now, then blend using a soft torchon or cottonbud.

ILLUSTRATION BOARD

The board used for this project has a smooth surface, which means you can blend the colours using a soft torchon, which is rather like a ball of cotton wool. You can also use a cottonbud where space is more restricted (see below). If you make a mistake, simply rub it out with a putty rubber.

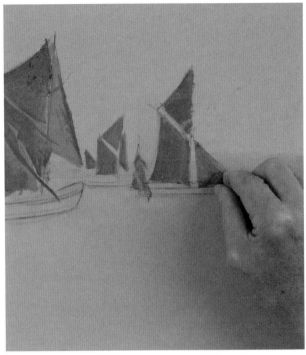

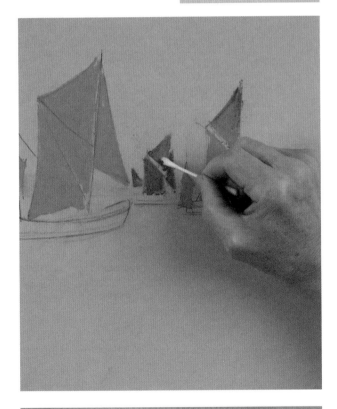

STEP 3 ▸▸

Take the same dark burnt sienna for the nearest sails and strengthen the reds using burnt sienna. Always try to get colour on the board in one stroke if you can.

RIGHT Now use yellow ochre to get some detail on the decks. Use the tip of the yellow ochre to create flat edges. Do not worry too much about accuracy: you can overdraw or lift out colour if it is not looking right. The decks that are farthest away have less detail, so the drawing lines are finer.

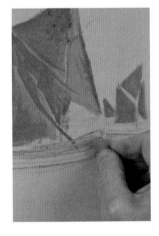

STEP 4 ▸▸

4
thames barge race

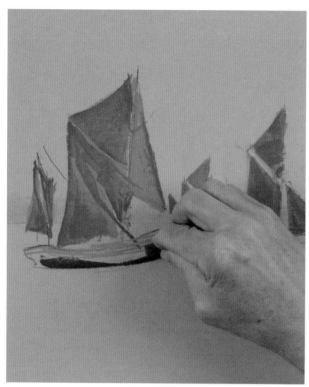

RIGHT Use the corner of the pastel for more intricate areas. Do not labor over detail at this stage, however. It is important to keep sketching fairly freely.

Add some sails in the distance. These are from barges that cannot be seen, but they add texture to the work. Continue to sketch in more detail.

Draw the dark sides of the hulls using a square-edged Payne's gray pastel. Hold it at a slight angle as you work it along the hull.

RIGHT Start to add some detail, sharpening up some of the lines on the boats. Still using the edge of the square-edged pastel, bring it down the board to produce straight but broken lines for the rigging. This is more convincing than trying to draw a continuous line with the pastel.

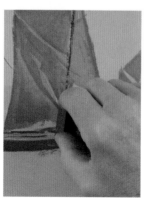

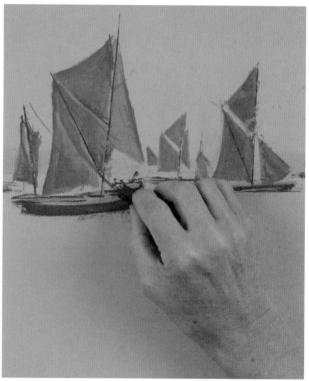

STEP 5 ▶▶

STEP 6 ▶▶

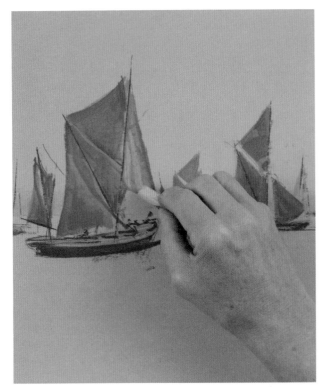

Clean up the background around all the boats using a putty rubber, before starting to work on the sky using the white pastel. Begin to lay down colour, using the whole length of the pastel and dragging it evenly on the smooth board. This way, you will still get textural marks of the paper showing through, which adds to the overall effect.

NEATENING EDGES

In a composition with lots of strong geometric shapes, such as these barges, you do not want soft-focus edges. The easiest way to neaten around these shapes is to use a putty rubber. For tiny areas, cut small pieces from the rubber so that you can flick out colour you do not want with precision.

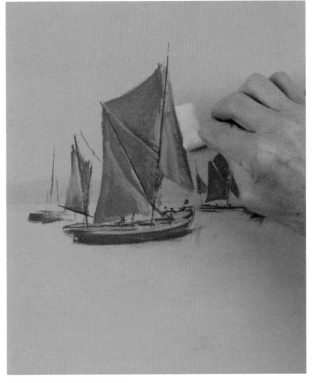

Now add some yellow ochre to the sails in the foreground, to give an impression of light. Leave the sails in the background dark.

RIGHT Take some more burnt sienna and use it to make the sails in the foreground redder. Continue to work across the sails until you have established the three dominant tones of colour.

STEP 7 ▸▸

STEP 8 ▸▸

4
thames barge race

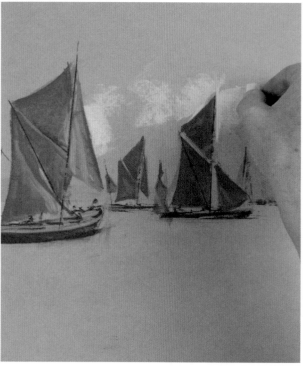

Slightly raise the tone of the water between the vessels, filling in the tones between the masts. Choose a colour that is close to the board colour. Here a pale yellow ochre is used, running it between the sails, which is slightly lighter than the board. Take the pastel across the water on its side and use the tip of the stick between the sails.

CREATING UNITY

If you work the whole painting in similar-sized pastels there will be a unity in the finished result. As your skill level improves you will be able to work in greater detail, even with larger-sized pastels.

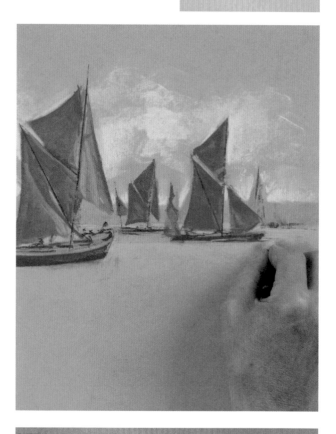

Make the clearest marks between the boats so that you can see where the horizon is. Push the pastel up the paper and lift it off at the end of a stroke.

RIGHT Scrub the sky colour around and between the boats and up into the sky area. Bring some stronger marks into the centre of the sky but do not overdo the sky. It does not need to have a great deal of detail in it.

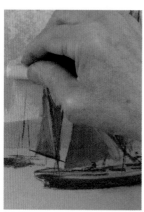

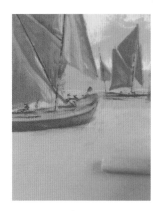

RIGHT Work some pale violet into the sea, using a whole pastel. Rub some violet into the clouds with your finger to establish a relationship between sky and sea.

Sharpen a charcoal pencil and use this for the rigging. Keep the forms on the decks as linear as possible. Neaten the edges of the sails, but do not outline them. Work lightly so that the charcoal almost disappears into the pastel.

Take a look at some of the more detailed rigging and use a cottonbud to create details and clean up edges.

TRICK OF THE TRADE

Once you are quite advanced with a drawing, you may find yourself working backward and forward over the work to add the finer details. If this is the case, you may find it useful to rest your hand on a brush handle or mahl stick to avoid touching the piece with chalky hands.

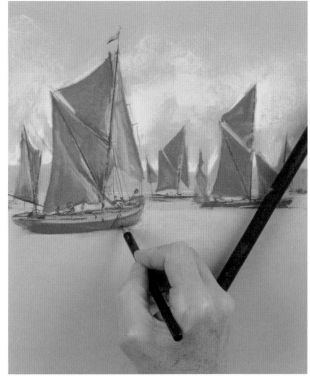

STEP 11 ▶▶

STEP 12 ▶▶

4 thames barge race

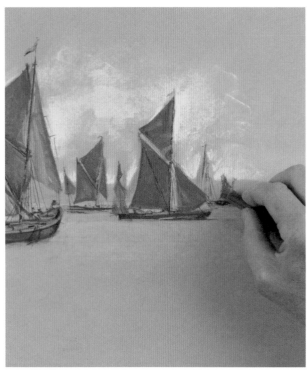

Take a cadmium red pastel and work it on the keel of the large boat in the foreground, using just the tip of the stick to apply the colour evenly.

Add another boat in the distance, drawing a sail on the right using the darkest burnt sienna pastel from step 3. This helps to balance the composition.

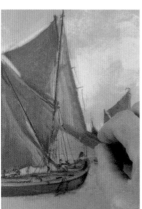

RIGHT Use the same dark burnt sienna to define the bottom of the sail in the foreground. Use a torchon in a cross-hatching manner to blend the colour in.

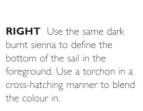

STEP 13 ▶▶

STEP 14 ▶▶

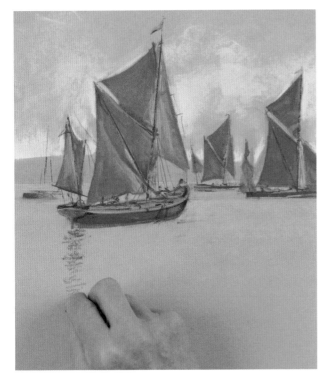

Continue in this manner for all of the reflections in the water, working some dark burnt sienna into them if they are too red. Add some darks here and there, then work some colour into the water, using pale violet and pale yellow ochre. Use the violet pastel on its side, taking it right across the water, to give some silvery reflections.

BE CONFIDENT

It can take time and effort to build up the reflections in the water. Hundreds of little marks are apparent in nature and, somehow, you need to imitate this. Work gradually and rhythmically, keeping the lines finer for the vessels in the distance and adding both darks and lights to show how the water catches the light.

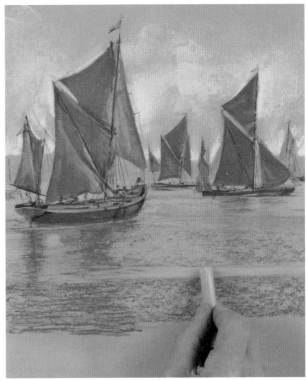

Start work on the reflections at the back of the boat. Using a little burnt sienna, work lightly to and fro down the board, keeping your movements rhythmic and parallel. Toward the bottom, manipulate the pastel to get more of a curve in the marks.

RIGHT The reflections on the right are paler and go down a long way into the water. Blend using the soft torchon, taking it right across the reflections and down the board in parallel lines.

STEP 15 ▶▶

STEP 16 ▶▶

RIGHT Use a slightly stronger cobalt blue to work some more colour into the sky between the sails if the colour looks a bit flat here. Now take the white pastel and start to indicate the markings on the deck.

Pick out a few highlights using a pale yellow ochre pastel.

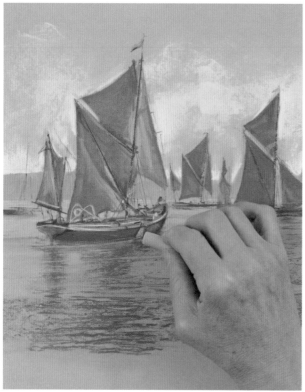

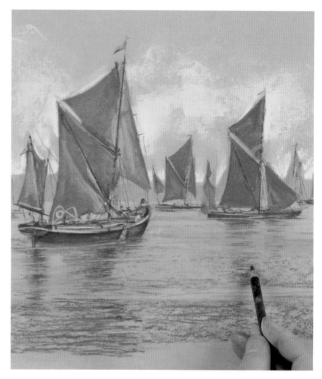

Strengthen some of the reflections using the charcoal pencil and working in parallel lines. Darken the reflection of the hulls in the water. Look at the drawing to see if you are happy with it. It is clear, in this instance, that the reflection in the foreground needs some pale violet worked into it.

BE CONFIDENT

If your reflections work, leave well alone. It is very easy to overdo it, thereby spoiling the effect. If, however, you are not convinced by a reflection you make, you need to work on it some more. In this drawing, the reflection in the foreground was not working and had to be modified (compare pictures in step 18 and 19).

RIGHT Tidy up the sky between and around the sails. Bear in mind that the basic colour of your board defines the tones of the whole painting.

Clearly separate the sails, using the white pastel, blending in places with your little finger.

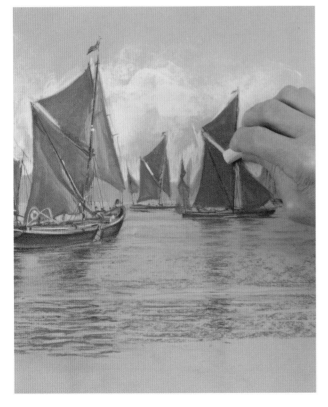

Still using the white pastel, add light shapes into the sails, just as you would if working on an oil painting. These little light shapes really make a difference to the whole piece.

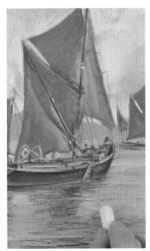

RIGHT Add a couple of lights into the water for sparkle, but do not overdo it, as your drawing may start to look chalky.

STEP 19 ▶▶

STEP 20

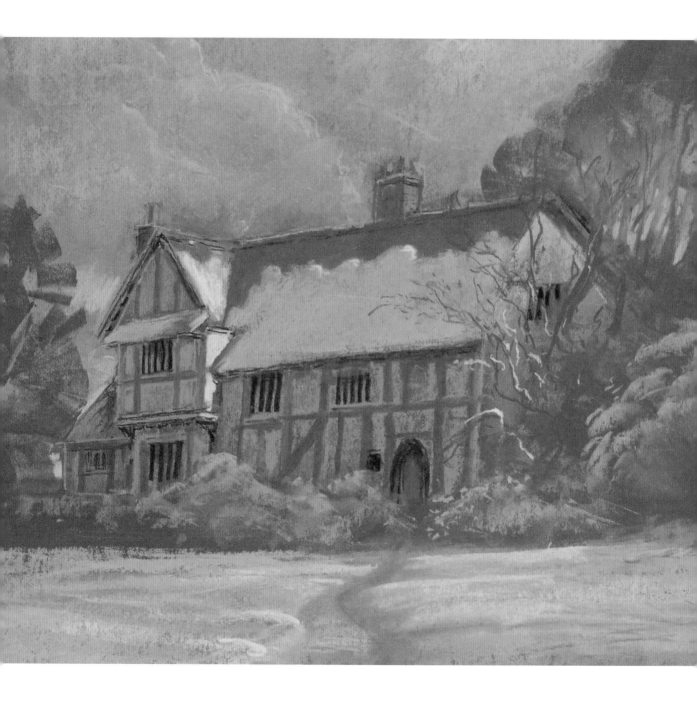

5
house in the snow
john barber
500 x 375mm (20 x 15in)

The subject of this project is an ancient farmhouse in Suffolk, England, dating back to the 15th century. It is just a few steps from John Constable's Flatford Mill and, in fact, was drawn by him. With an old, wooden-framed building like this, the crookedness is part of the interest, so do not worry too much if your lines are not perfectly upright. Starting with a grey-tinted paper gives us a middle tone that already suggests a winter's day and provides a dramatic contrast to the snow-covered areas without having to make them too white. Showing only part of the roof covered in snow breaks up a large area which would overpower the delicate detail of the building if it were completely covered or all bare tiles.

TECHNIQUES FOR THE PROJECT

Line drawing

Stippling foliage

Blending

WHAT YOU WILL NEED

Grey cover paper
White chalk pencil
Torchons
Cottonbuds

COLOUR MIXES

1 **Payne's gray**
2 **Viridian**
3 **Burnt sienna**
4 **Yellow ochre**
10 **Violet**
11 **Cobalt blue**

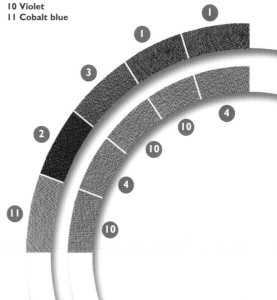

WORKING FROM DARK TO LIGHT

In the previous project, we talked about the use of the middle tone, but in this exercise we take as our starting point a background colour that is considerably darker, so that in the 'house in the snow' project most of our colours are lighter than the background; colours that are darker than the background are few. In the exercise, we begin with colours that are only slightly lighter than the background and work our way up to pure white. Clouds are excellent subjects for this sort of experiment, as there is no limit to what colours or shapes you may see in the sky. Although not illustrated here, blending with the fingers is an excellent way of working from a dark ground. Using your fingers gives you a subtlety of gradation so that edges fade to nothing. When you cannot see where the chalk ends and the background paper begins, you are becoming a competent pastel artist and will be able to apply this skill to a wide range of subjects, but most easily in your skies. The darker your background, the brighter will your chalk-based colours appear, so for strong contrast try some very dark papers, even black, but avoid bright colours unless you want all your hues to be influenced by that colour. It is down to personal preference, but many artists prefer to build colourful pastel paintings in a neutral tone. Experiment and try out all options for yourself.

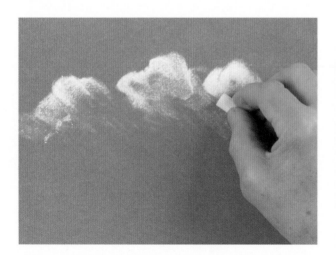

1 Take a mid-toned paper and use a very pale yellow ochre pastel to sketch out the tops of some clouds. Then start to scrub some more colour into some areas to give an impression that the clouds have some body.

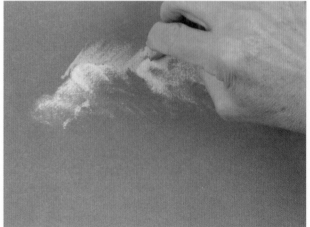

2 Now select a pale ultramarine pastel and use this to define the tops of the white clouds. Scrub this on its side around the top of the yellow ochre as you begin to create the main area of the blue sky.

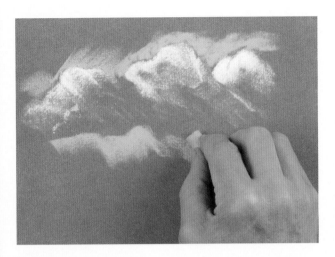

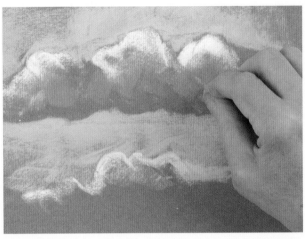

3 When you have worked around the tops of the clouds, create a second area of blue sky beneath the clouds, then define the lower edge of this area of sky using the yellow ochre pastel. This suggests another bank of clouds.

4 Add areas of Payne's gray into your white clouds, then work some darker ultramarine into the central area of sky. Take your ultramarine sky colour right up to the top edge of your paper. Keep the colour fairly flat at this stage.

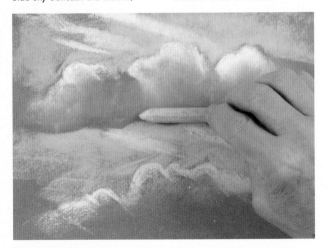

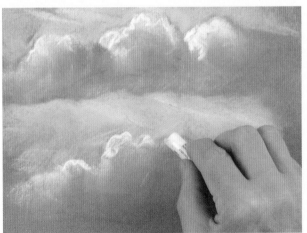

5 Now that all the flat patches of colour are in place, they can be blended together. Use a torchon over the whole sketch to blend the colours so that their edges become obscured and each colour flows into the next, as they do in nature.

6 Then use a white pastel to pick out some highlights in the tops of the clouds. Blend these highlights using your finger. Do not overdo the white highlights: your skies will be more convincing if you are restrained in your use of white.

5

house in the snow

Sketch out the main lines of the composition using a white chalk pencil. Concentrate on just the main shapes for now and on drawing them in perspective.

REMEMBER

The most important thing is to get the shape of the building against the sky, rather than trying slavishly to copy the building. Parts of this building date back to the 14th century and it has had many additions and alterations since then. If your perspective is not quite right, do not worry: this will not detract from your finished drawing.

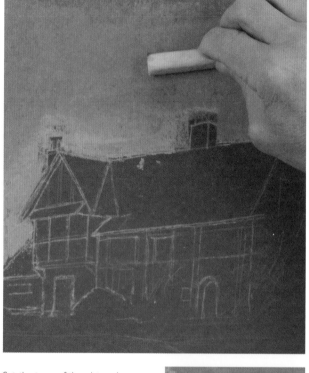

Set the tone of the picture by isolating the house from the sky. Use a light Payne's gray pastel on its side and work around the roof of the house to establish the silhouette of the house against the sky. Rub the sky in with a torchon to create a beautiful soft grey colour.

RIGHT Introduce some pale yellow ochre to create more interest and blend this in with a torchon. Add pale violet so that the sky is no longer simply grey.

STEP 1 ▶▶

STEP 2 ▶▶

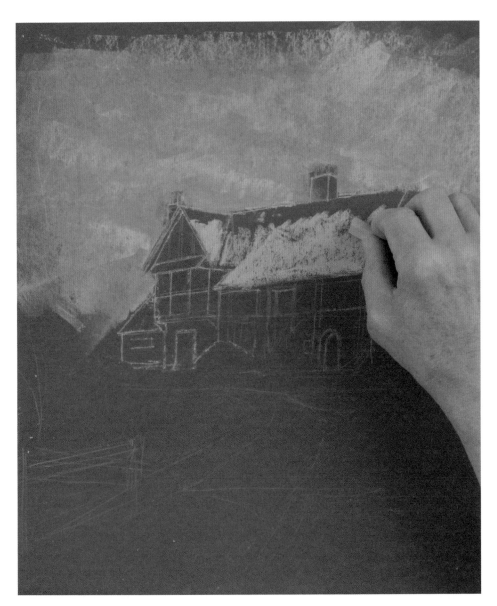

PASTEL SELECTION

For the best results with this medium, it is essential to have the widest possible range of pastels. Buy the biggest selection you can afford and add to it as you go. This way, you will be able to mix a greater variety of colours and tints.

Use the same pale violet on the roof so that the sky and snow on the roof have some relationship to each other. Apply the colour evenly across the roof, using the pastel on its side.

STEP 3 ▸▸

5
house in the snow

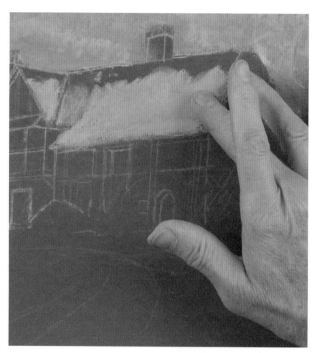

Where the snow has started to slip down, the rich terracotta colour of the roof is visible. Use burnt sienna to work the gable to the left first, then continue across the roof. Slightly smooth some of these tones off. Leave the area to the right of the house for now –

you will be positioning trees here later. Add some light violet to the bay roof at the gable end and to areas of the ground in the foreground. In these areas, suggest that there could be snow resting on bushes. Again, this enhances the atmosphere.

Blend the roof colour with your finger to give it an even tone.

RIGHT The building itself needs to be a neutral tone, but you do not want to lose the definition of the architecture. Rub some of the pale violet into the front and side of the house to enhance the atmosphere of the scene: the house in the snow.

STEP 4 ▸▸

STEP 5 ▸▸

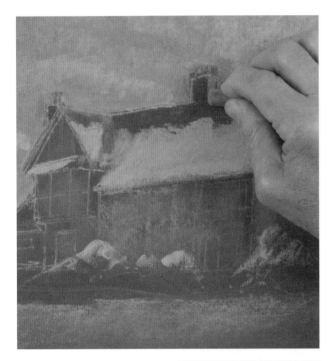

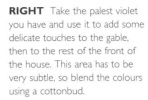

RIGHT Take the palest violet you have and use it to add some delicate touches to the gable, then to the rest of the front of the house. This area has to be very subtle, so blend the colours using a cottonbud.

For the walls of the house, take a neutral, pale, yellow ochre. Apply sparingly, without losing the underlying drawing and blend the colour with your finger.

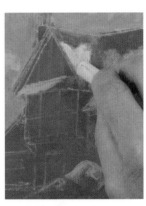

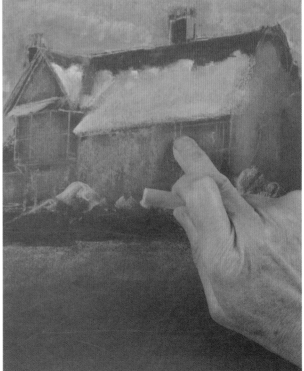

Use a paler burnt sienna for the side of the chimney that is catching the light.

RIGHT Now start to work up some detail in the house. Use a torchon or cottonbud to blend the colours on the roof.

STEP 6 ▶▶

STEP 7 ▶▶

5
house in the snow

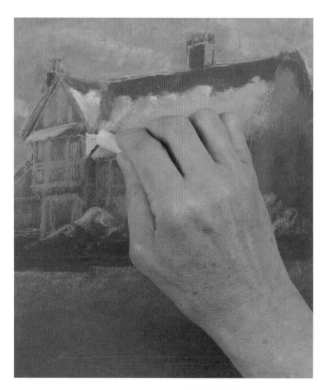

RIGHT With a sharp, black chalk, redefine some areas of the drawing. Work some detail into the eaves and the windows.

Re-establish the timbers of the gable using a slightly darker Payne's gray. It is important to keep the building fairly subdued so that the house does not overpower the snow in the foreground when it comes to working the lights and highlights. Use the torchon to smooth some of these lines off.

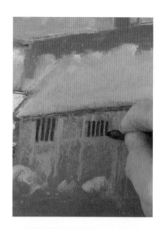

Use a tone of Payne's gray to indicate some of the beams on the gable end of the house. The beams here are not very dark: they are unpainted natural oak. Notice how the light catches the side of the gable and work a light triangle of colour using the palest yellow ochre you have. Use the same colour to work the nearest end of the main building.

REMEMBER

Once you start to add more detail, you will be working over areas that already have pastel on them. Don't forget to rest your hand on a mahl stick or brush handle to avoid smudging the existing drawing as you do so.

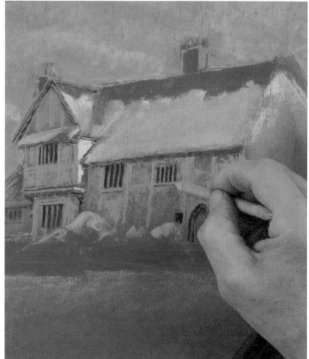

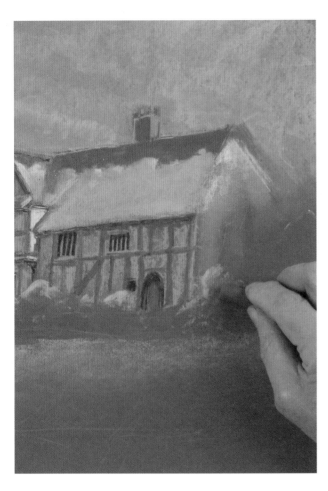

Use a pale violet pastel to draw in the snowline on the low roof at the gable end of the house. Use your finger to blur this off into the sky colour. Introduce more defining lines around the house, before moving on to the foreground, using the pale violet to work around the roofline. Soften and blend using your finger or a torchon. Use a cottonbud for the most detailed areas where your finger is too large to blend effectively.

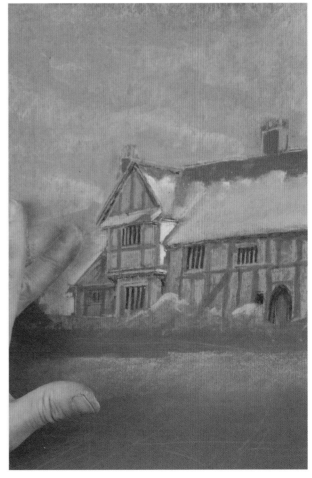

Define the timbers on the front of the house using Payne's gray. Take a dark viridian green and start to indicate some foliage to the right of the house. Scrub this colour in. Continue to work foliage across the front of the house, picking out the highlights using yellow ochre.

STEP 10 ▶▶

STEP 11 ▶▶

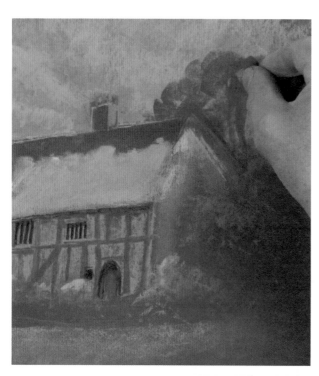

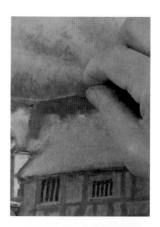

RIGHT Now take some darks into the sky. Apply a little Payne's gray above the roof and blend this in with a torchon.

This brings out the lightness of the roof. It does not matter if you have 'lines' in the sky – they are often there. Blend some of the colours together. Use your thumb to smooth off the colour above the roof if you wish.

Use Payne's gray to indicate the basic shapes of some trees to the left of the building. These do not need much work: a few marks made using the pastel on its side will be enough. Use the same colour to position some trees behind the house on the right, giving more definition to the roofline of the house.

BE CONFIDENT

Aim to make marks that you can leave without altering. This depends on whether you can control the shapes that the pastel makes by breaking the pastel into the right length and learning to manipulate it between finger and thumb. Look at what shape and size of marks you need to make, then practice on paper until you can repeat them with confidence.

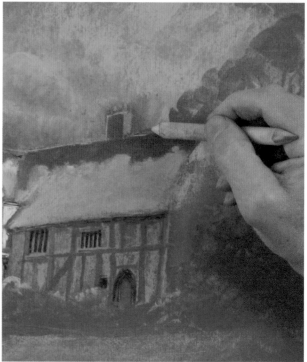

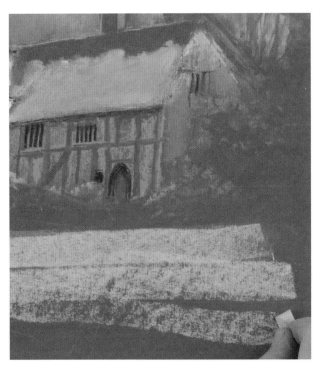

RIGHT With a clean torchon used on its side, blend the colour in. Draw the ribbon-shaped path and some banked snow using Payne's gray and blur the edges using the side of the torchon.

Work some more very pale cobalt into the foreground to build up the snow and add some areas of the light violet you used for the roof. Work some shadows using Payne's gray and then blur them using a torchon.

Take a very pale cobalt blue and start to lay down colour in the foreground, working from left to right across and down the paper. Apply the colour evenly, avoiding areas of shadow. Get plenty of pastel on the paper.

COLOURING SNOW

Keep away from pure white for the snow. This will make it look chalky and dead. Snow almost always has some colour in it – in this example, very pale blues and violets. Make sure all areas of snow have the same colours running through them so that they relate to one another. This is important for the success of your drawing.

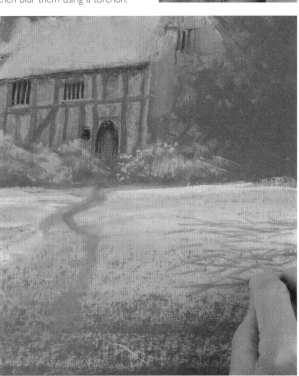

5

house in the snow

RIGHT Use a cobalt blue pastel to work some more definite edges to the clouds in the sky and smooth these off with your little finger.

Work some pale yellow ochre into the sky behind the trees to make it look more cream in colour.
If you prefer, use a mahl stick to steady your hand as you work these finer details.

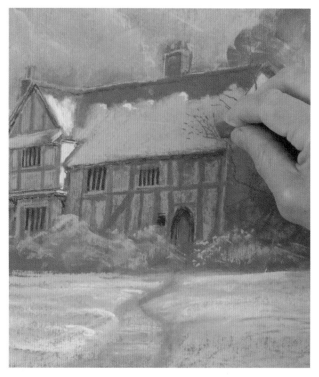

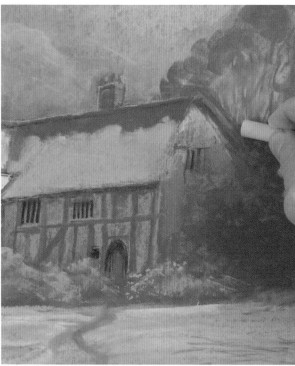

Take the Payne's gray and use it to create some very delicate branches coming across the house in the foreground.

TRICK OF THE TRADE

If you find it difficult to draw fine lines holding your hard pastel with your fingers, you can use a crayon holder. This is basically a tube with a collar for gripping a piece of pastel or charcoal. Such holders are useful when you need a fine point, but prevent you from using the side of the pastel.

Add some highlights to the very brightest areas of snow on the roof, on the tree branches and the shrubs and in the foreground using a white pastel. Draw a torchon across the snow to blend the white highlights into the snow. Then look at all your areas of light and shadow to check that they are reading as you want

them to. In this instance, having added highlights to the snow in the foreground, it was clear that the path had started to look less certain, so its shape was redefined using a cottonbud. This also reinforces the indications of banked snow on each side of the path, adding to the realism of the finished scene.

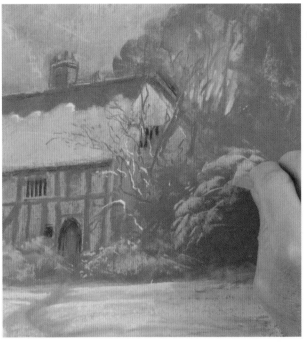

Use the cobalt blue pastel to add those areas of snow that fall into shadow. Add some fine highlights to the bare branches of the tree in the foreground and lay down colour for the snow on the shrub to the right.

RIGHT Blend the cobalt blue pastel with your finger to complete the drawing.

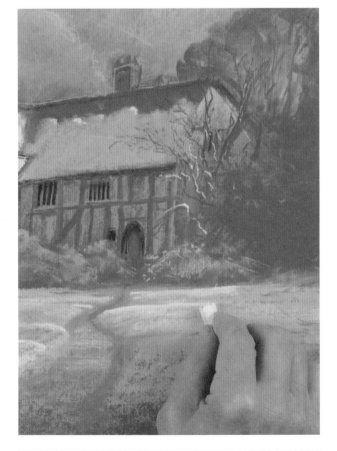

STEP 17 ▶▶

STEP 18

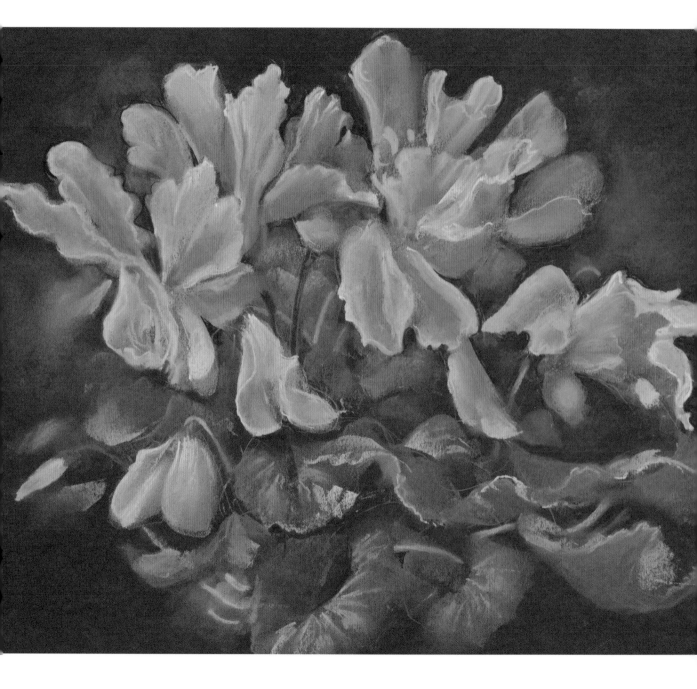

6

flowering cyclamen

john barber
400 x 500 mm (16 x 20 in)

Here there is the chance to enjoy pushing the pastels around, using bright colours to create the maximum contrast on the black background – the full power of pastel colours has its greatest effect on a dark surface. By drawing your blossoms larger than life, you will find it easier to make the petal and leaf shapes with the side of the pastel, often with a single stroke. Overlapping strokes will quite quickly give a sense of the third dimension. This project is planned to get you relaxed about the way you draw with pastels. In plant studies like this, painterly enjoyment of colour and rhythm are more important than botanical detail. Dancing lines and bright colours freely handled, will make a light-hearted, attractive picture.

WHAT YOU WILL NEED

Black cover paper
White chalk
Round hoghair brush, no. 6
Putty rubber
Mahl stick

COLOUR MIXES

1 **Payne's gray**
2 **Viridian**
3 **Burnt sienna**
9 **Permanent rose**

TECHNIQUES FOR THE PROJECT

Blending using your fingers

Creating highlights

Blending using a brush

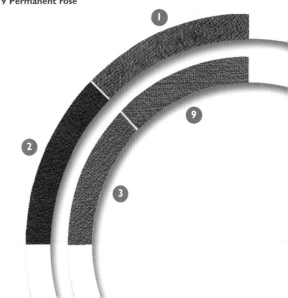

flowering cyclamen / techniques

CREATING SHAPES ON A DARK BACKGROUND

Here for the purposes of demonstrating the extreme contrasts between a dark background and our bright pastels, we have used the ultimate contrast: black mounting board. Every mark on black made with a chalk-based pastel will have the maximum effect. In this exercise, by the time you have reached step 4, the subject is sufficiently developed for a whole composition to be carried out at this degree of finish. Indeed you may wish to keep to this, or make your painting even more free. With this kind of contrast, you are working in the same way as someone handling a woodcut or linocut, a technique where you have constantly to think in reverse

so that every cut you make will, in the end, come out as white against the dark, inked background. The instant gratification we get when we use scraper board and see pure white lines appearing from the perfectly flat black board is similar to the way our pastel strokes affect a black ground. The subject of cyclamens is certainly colourful and full of dramatic tonal contrasts. Drawing the blossoms larger than life helps in allowing the pastel to be moved around the board. Although the strong contrasts work for the purposes of demonstration, it would be good to go on and blend some softer tones into the background and blur a few edges.

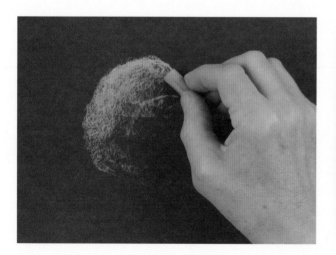

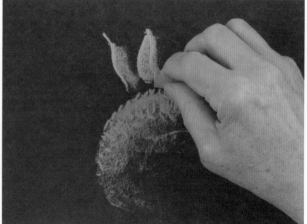

1 Start with a light yellow ochre pastel and use this to begin to define the edges of the centre of the sunflower. Use the pastel on its side and define the circular centre of the bloom: turn your paper around if you need to.

2 Then start to add in some simply shaped petals. Work around the centre of the bloom, adding in petals. Keep the colour in these flat. This step shows clearly how dramatically pale shapes can be lifted out of a dark background.

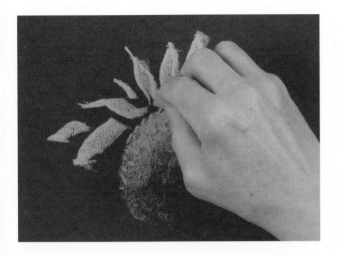

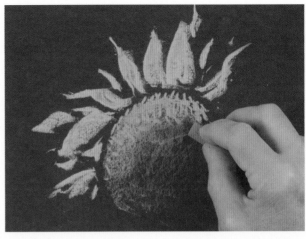

3 Work into these petals with a pale yellow pastel to create some areas of highlight. These patches at the moment are still reading only as areas of flat colour. Don't get too 'tight' over these marks: keep them loose and flowing.

4 In the centre of the flower, use the side of the orange pastel to preserve the textural marks of the surface of the paper. All these little dark areas of paper where no pastel adheres suggest shapes that can be worked into later.

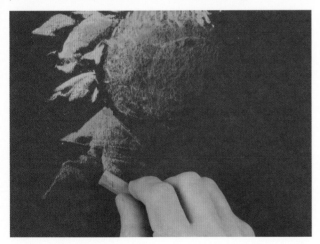

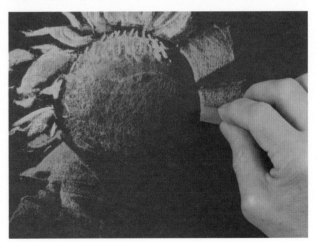

5 It is up to you how far you want to take this sketch: it is finished when you are happy with it. In this demonstration, there is a suggestion of leaves, worked using a pastel from the darker end of the range of yellow ochre pastels.

6 The bright marks of the flower and leaves jump out at the viewer because they are worked on a dark paper. Fade and feather all the marks at the edges into the black background. There is no blending in this sketch.

6
flowering cyclamen

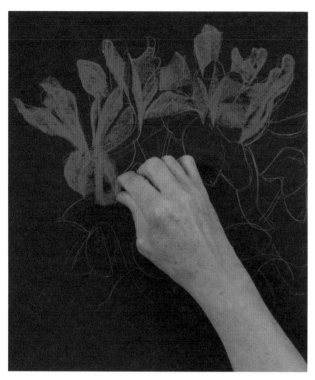

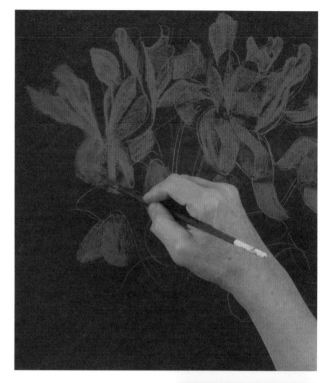

Use a white chalk to sketch in the main lines of your composition. Establish a medium tone for the blossoms first, using a long, bright, permanent rose pastel to create dramatic shapes. Then cut the pastel down so that you can hold it between finger and thumb. Use this to create individual petals, keeping the pastel on the paper for each one and pushing plenty of pigment into the paper. Outline one petal against another to achieve a change of tone.

REMEMBER

When sketching your outline, plan out your groups of blossoms to make a good arrangement on the paper. Notice particularly the gaps between the petals, as these will give you your dark tones. Do not go into great detail here, but look at the shapes of the flowers rather than individual petals.

Blend some of this initial toning, using a round hoghair brush.

RIGHT Once you have some colour on the brush, you can use it to help shape the petals. The brush becomes your drawing tool, pushing the powdery pigment around your paper.

STEP 1 ▸▸

STEP 2 ▸▸

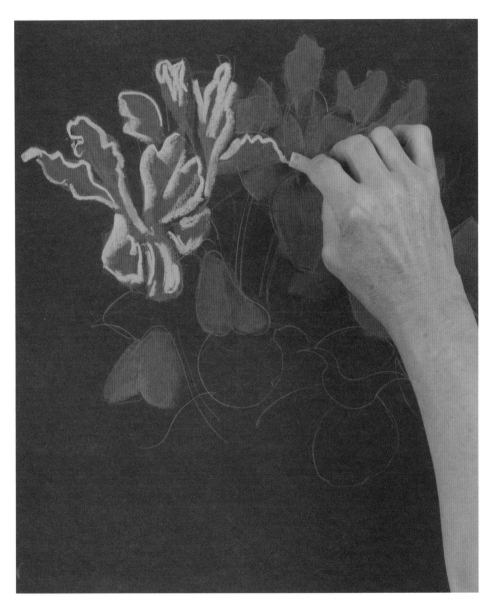

BE CONFIDENT

Do not worry about getting pink pigment onto areas where you do not want it. It is easy to add a background, or cover them later. False shapes are no problem at this stage when you are still simply getting colour and shape onto the paper. Ambiguities can always be addressed later.

Now begin to look at the edges of the petals and start using a lighter tone of permanent rose around them. Work across the plant, adding pale pink edges to all of the petals.

STEP 3

6
flowering cyclamen

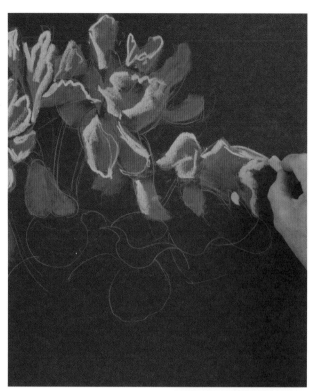

RIGHT With your finger, blur the hard edges. Always blend from the outer edges in toward the centre of the flower. Accidental marks will then be in the petals and not outside them.

Blend in some more of the bright pink so that some strength of colour is re-established. This may need blending again in places: some petals are blush pink while others fade almost to white.

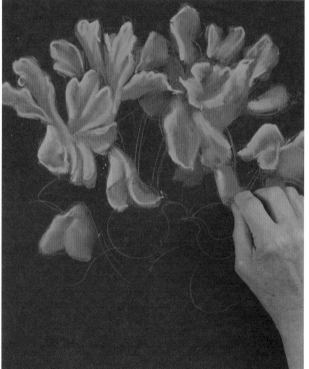

Keep looking at your plant, to establish where the lighter areas fall on each petal and draw them in carefully.

RIGHT Use just the tip of the pastel to add the most delicate highlights around the edges of the petals.

STEP 4 ▸▸

STEP 5 ▸▸

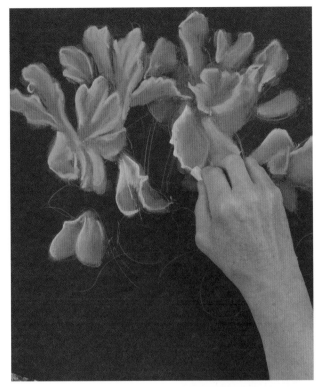

Continue to work across the blossoms, adding in the lightest tones. The pressure of the lighter pastel on the darker tones blends the colour to a certain extent. Use the slightest touch of your little finger to complete the effect. Once you have blended everything, use your lightest permanent rose pastel to work some fine details into the petals. Use these to define where the petal shapes change direction, turning away from the light.

TRICK OF THE TRADE

If you can, it is often better to work left to right, if you are right-handed and top to bottom. That way you do not risk moving colour around from areas that you consider almost finished. Do not worry if the pastel breaks as you work: this is normal, especially if you apply the right amount of pressure. Simply blow away any crumbs and continue working.

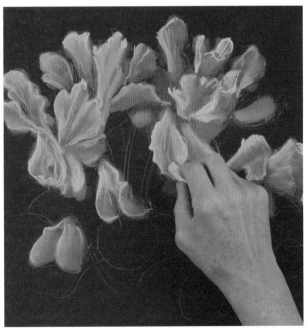

Take the palest shade of permanent rose as your lightest colour. Sharpen it, if necessary and use the edge of the pastel to silhouette the petal edges. Wriggle the end of the pastel a little to achieve the indentations of the very edges of the petals.

RIGHT Do not worry about drawing with absolute accuracy: you are creating an impression of the edge of the petal.

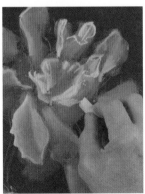

STEP 6 ▶▶

STEP 7 ▶▶

6
flowering cyclamen

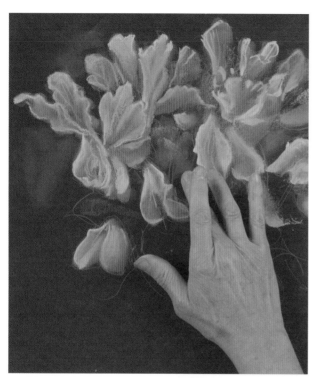

RIGHT It is now time to start working on the green leaves. Once these are in place, it will be easier to balance the lights in the blooms. Start to establish the shapes of those leaves that are catching the light.

Use pure viridian to start with. Bear in mind that the brightness of the viridian will be dulled by the black of the paper and will will not look as bright as it would on a pale background.

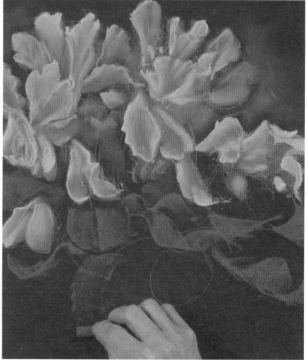

Lay on a grey background colour to soften some of the blackness of the paper (although you can leave the black paper showing around the petals). Do this by blending a little Payne's gray with the light pink and soften with your finger.

RIGHT You do not want to lose the 'blushing' effect of the blooms, so add some more bright pink where necessary.

STEP 8 ▸▸

STEP 9 ▸▸

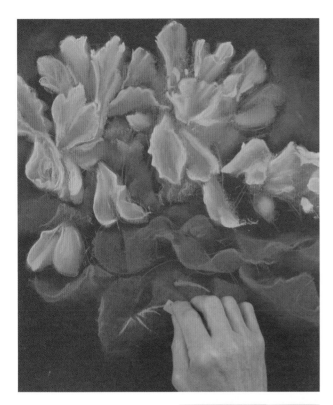

RIGHT In some cases the leaves are as interesting as the flowers, if not more so, but resist the temptation to make them too detailed or you run the risk of the foliage overpowering the beautiful blooms.

Sharpen the edges of the leaves and shape and clean up the edges of the petals using the edge of a putty rubber.

Establish a base tone for the leaves by blending the green using a round hoghair brush. Take an olive green pastel and use this to delineate some of the edges of the leaves. Soften these lines with your finger.

RIGHT Now use a lighter tone of viridian to draw finer details on the leaves themselves and again soften with your finger.

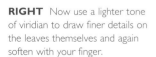

STEP 10 ▶▶

STEP 11 ▶▶

6
flowering cyclamen

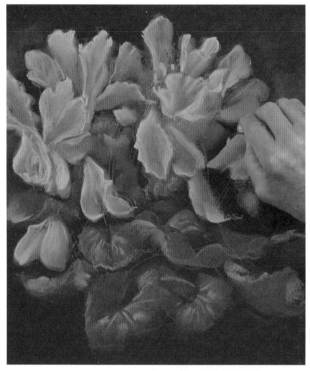

RIGHT Now take a burnt sienna pastel and use it to draw some of the lighter stalks in the centre of the blossoms.

If they look too prominent, knock them back a little using a stiff, flat hoghair brush. Draw some stalks between the leaves at the bottom of the picture.

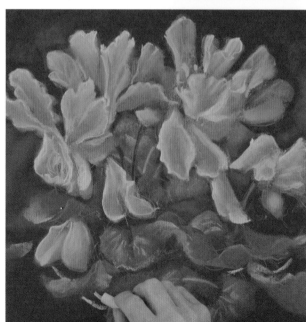

Around the edge of the blooms, use the corner of the rubber to take out a tiny shape defining the gap between two petals.

RIGHT In the centre of the drawing, rub out some of the grey background so that the black of the paper shows through to serve as one or two of the darker plant stems.

STEP 12 ▸▸

STEP 13 ▸▸

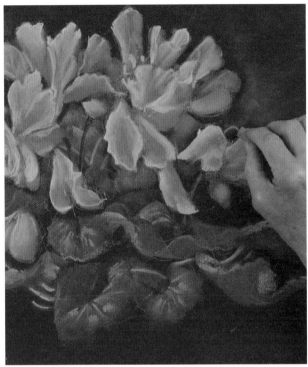

RIGHT Take the pure white pastel and sharpen its end to a point so that you can work some finer details. These 'dancing' white lines bring a sense of rhythm to the petals: taking the eye from one to the next.

Use the square end of the pastel for larger areas. If you overdo the white, you risk spoiling the success of the piece, so use this pastel with restraint.

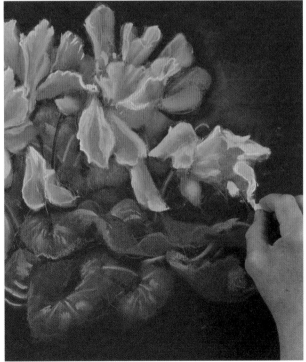

Most of the stems are out of view and others disappear behind a bloom or into the leaves at some point. Do not overdo them, but look at the plant to see where they are visible.

RIGHT Make sure that you do not leave any blooms 'floating' in mid-air.

STEP I4 ▶▶

STEP I5 ▶▶

6
flowering cyclamen

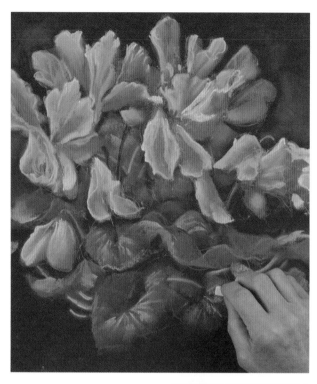

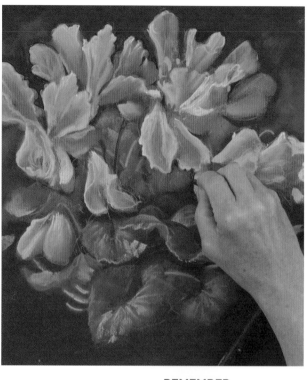

Now use the white pastel to add some details to the leaves.

RIGHT Apply sparingly, making a number of small, interesting marks and then blend to make the colour change more subtle.

Take the black pastel and use it to make indentations into the petals. Rest your hand on a mahl stick or a brush handle to prevent your hand from smudging your work.

REMEMBER

The three main things that matter in a flower painting are irradiation and rhythm of lines, cleanness of shape and purity of colour. Pastels can create all three as successfully as any other art medium.

STEP 16 ▸▸

STEP 17 ▸▸

Continue to use the black pastel in this way, working around the petals, sharpening and redefining their edges. Do not overdo the black marks, or the colour may start looking too 'sooty'. Blur some of the harder edges to create a more out-of-focus look to the drawing, then clean up around the edges of the petals, leaves and background using the putty rubber.

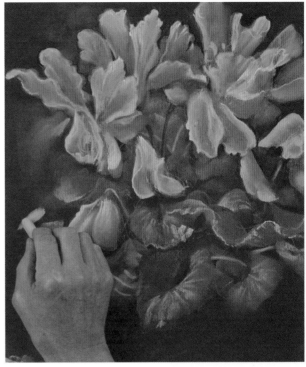

Stand back to look at your drawing and add any final details. In this instance, the balance does not look quite right, so a bud is added on the left-hand side, with an indication of a leaf. Draw the basic bud shape using the lighter permanent rose pastel.

RIGHT Add a stem and finish the bud with a hint of the darker permanent rose colour. This now balances out the blooms on the right and completes the drawing.

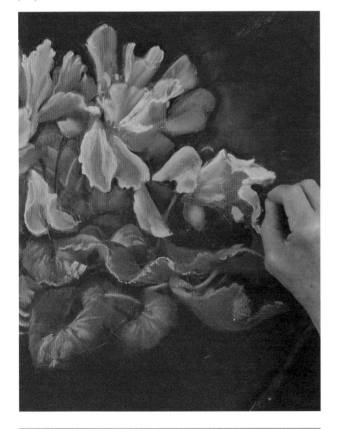

STEP 18 ▶▶

STEP 19

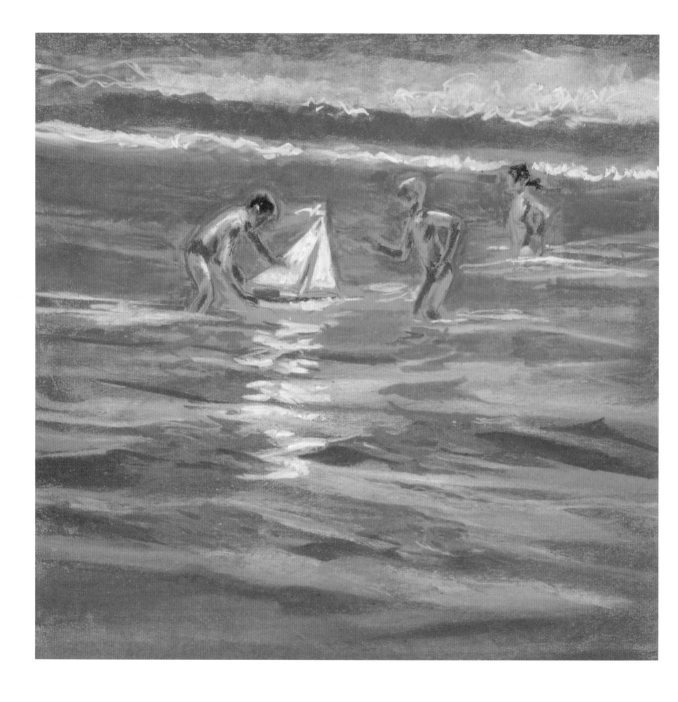

7

playing in the shallows

john barber

290 x 300mm (11½ x 12in)

This little demonstration of the children playing in the waves is really just a memory of so many splendid beach scenes and bathers created by other artists, but hopefully it will get you interested in the way that the pastel medium, with its softly modulated colour ranges, can by a few interlocking wavy lines invoke an impression of sunlight on water. The way that a few short crumbly white lines can instantly suggest that this is the sea constantly surprises and delights. We know in our minds that these are only symbols or icons, but these chalk lines, inadequate as they are, still say sun and sea. Enjoy your trip to the seashore when you complete this project and may your lines flow like waves.

WHAT YOU WILL NEED

Buff illustration board
Graphite pencil, 3B
Cottonbud
Torchon

COLOUR MIXES

2 Viridian
3 Burnt sienna
4 Yellow ocher
11 Cobalt blue
12 Ultramarine

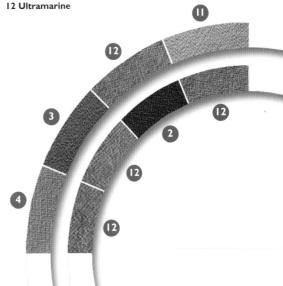

TECHNIQUES FOR THE PROJECT

Creating silhouettes

Using a torchon

REFLECTIONS AND RIPPLES

In this sketch of children in the shallow, sunlit waves and in the even simpler sketch on these pages, we begin to explore some of the ways of suggesting water in your paintings. When facing the challenge of portraying water, think of those artists who have struggled with the subject in the past and how their work might help you toward a personal way of seeing. Consider the great woodblock print of the falling wave by the Japanese Hokusai (1760–1849), with the clawlike foam along the crest towering above Mount Fuji and the fishing boats. Reproductions have hung in the studios of many great artists, including the composer Claude Debussy who is said to have based his composition 'La Mer' upon its proportions. Turner (1775–1851) also comes to mind: his rapid watercolours could very easily be adapted to pastel technique. In fact, he used the odd bit of chalk himself. Then we could turn to Monet (1840–1926), who painted the sea and water in so many ways from the great rolling waves on the French coast to the glistening reflections of the Parisian bathing places and the limpid waters of his lily pool. His work always repays study. So many of his paintings of water are carried out with brushstrokes that look almost as if done with the side of a pastel. Bold, broken strokes without too much blending would be the way to give your water painting a sparkle.

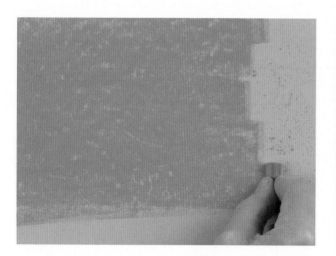

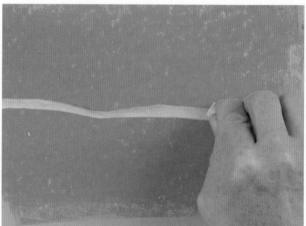

1 Start with a warm-toned buff-coloured paper with a good texture. Then use the side of the cobalt blue pastel to create a broad flat area of blue water. Work across and down the whole sheet to cover it with your blue colour.

2 Work some lighter shades of cobalt blue into your initial covering of colour, zigzagging down the paper. Then work a bold stripe of light viridian across the paper. Use the lightest tone of viridian in your box for this.

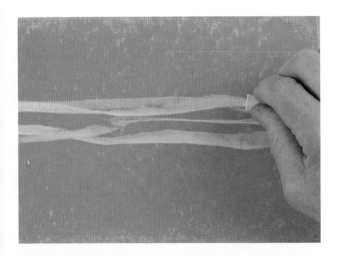

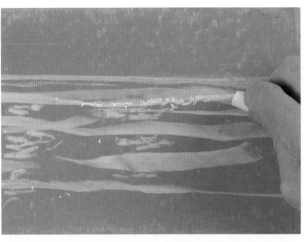

3 Still using the light tone of viridian, start creating marks between the white ripples. Take a broad sweeps of this colour across the paper. There is no blending at this stage: you are simply adding areas of colour to your sketch.

4 Add a solid white across the center. Do not worry if your pastel stick breaks: either blow off the crumbs or leave them to be incorporated in your sketch. Try to avoid breaking your stroke if a pastel breaks. Keep the pastel moving.

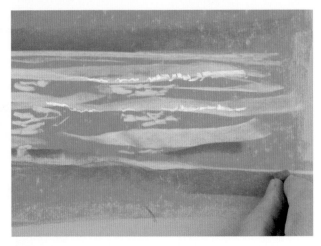

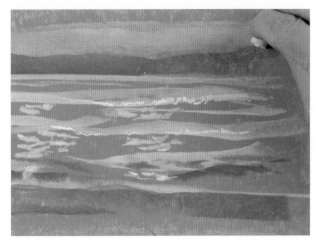

5 Then work in some darks using a cobalt blue from the deepest end of the colour range. Using very few tones of pastels, you are already building up a good impression of how to create believable water in your pastel paintings.

6 Finally, create an illusion of distance at the top of the sketch by using one of your palest blues. Pale colours tend to recede: you can use this phenomenon in your work when you want areas of landscape to appear more distant.

7
playing in the shallows

Use a 3B pencil to sketch out the children as basic shapes. You do not need to draw in any detail. Now use the tint of the board as your basic flesh colour and begin to outline the figures with a cobalt blue pastel. Use the tip of the pastel and control the marks as much as possible: you can always make alterations later.

TRICK OF THE TRADE

By using the pastel to outline the figures in this way, you are able to cut them out as silhouettes. This simplifies drawing figures. You can apply colour at a later stage to build up the flesh tones (see p. 135), but at this stage it is worth keeping your drawing as simple as you can.

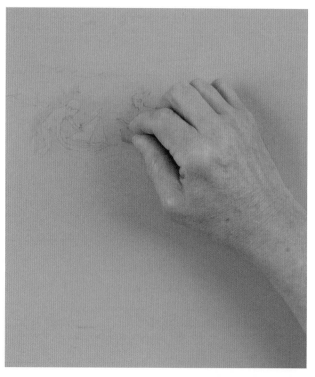

With the outlines complete, use the pastel on its side to apply broader areas of colour around the playing children.

RIGHT Take a cottonbud and use it to clean up those areas where the sea comes into contact with the figures. This gives them crisper outlines. Continue to build on the waves using the cobalt blue pastel.

STEP 1 ▶▶

STEP 2 ▶▶

Return to the figures of the children and start to introduce some modelling. Use a burnt sienna pastel sparingly to add spots of colour, here and there, to give a sense of contours on the bodies. Do the same on the boat

REMEMBER

When using the edge of a pastel, hold it firmly between your finger and thumb and make fairly precise marks.

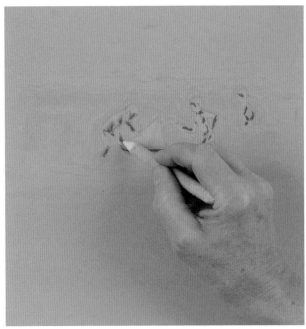

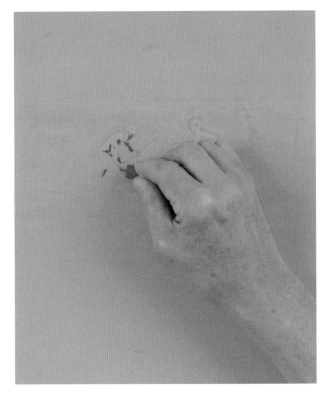

Now take a clean torchon (sharpen it if necessary) and blend the burnt sienna a little. Use a light yellow ocher pastel to put some colour into the little boy's hair and use a dark yellow ocher for the girl's hair, outlining the shape of her head. Blend the hair to make its shape more accurate, but do not overdo this.

RIGHT Give the children's swimsuits some colour. For this, use bright burnt sienna for the girl and a dark burnt sienna for the boy on the left.

STEP 3 ▶▶

STEP 4 ▶▶

7
playing in the shallows

RIGHT Having established the figures, start to work on their setting – the shallow water's edge. Begin with a broad band of solid blue to give an indication of the incoming waves.

This strong blue will be the base colour for all the other tones. Use half a pastel stick and move it back and forth across the paper, to drag colour into the foreground.

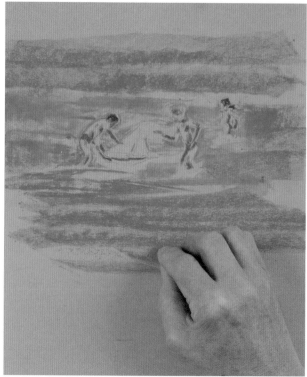

Use viridian to colour the swimsuit of the boy in the center of the drawing.

RIGHT With the tip of an ultramarine pastel, darken the sea a little, to increase the contrast between the figures and the water. As you work the darker blue into the lighter blue, the latter starts to blend into the former, so that the two colours mix and blend on the board.

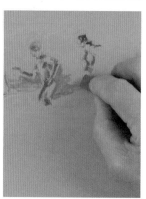

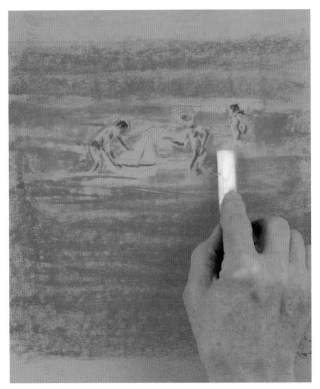

RIGHT The light crayon will pick up some solid ultramarine, helping you to blend more colour into the painting.

Work some of this light viridian into the top of the painting, adding crests to one or two of the incoming waves.

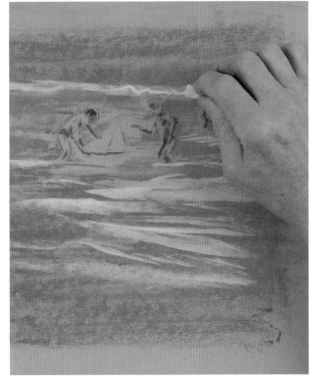

With the majority of the paper covered, take a torchon and use it to smooth out the marks: you will blend colour into these areas at a later stage.

RIGHT Add colour between the figures using a light viridian. Use this pastel too to establish some of the waves that are the background for the painting.

STEP 7 ▶▶

STEP 8 ▶▶

7
playing in the shallows

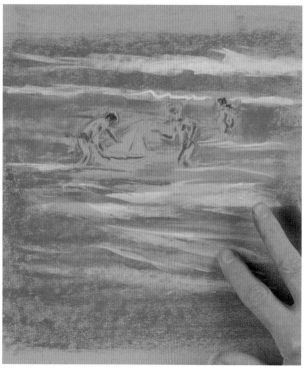

As you add the burnt sienna, you will notice that the rich earth yellow becomes stronger by being laid down alongside the most intense blues.

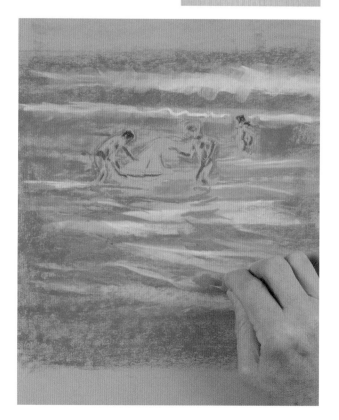

Start blending the viridian into the ultramarine using your finger.

RIGHT Take a light tone of burnt sienna to indicate the reflections of the figures, exaggerated by the water and the light. Do not be too precise about these shapes: abstract patches are more effective.

STEP 9 ▶▶

STEP 10 ▶▶

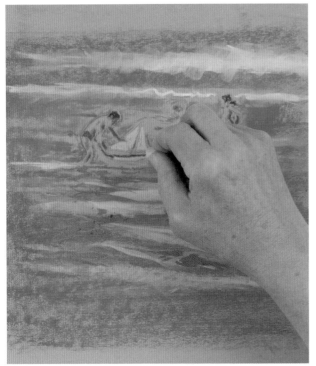

Slightly warm the crests of the waves with an earthy yellow ocher. As well as warming the waves, this also gives a colour relationship between the figures and the waves. It also brightens the overall effect of the drawing.

REFLECTIONS

No ripple or reflection is ever fixed, as water is constantly moving, Rely on the feeling of the pastel in your hand and if you see an effect you like, keep it. Remember that reflections are always darker than the objects they are reflecting.

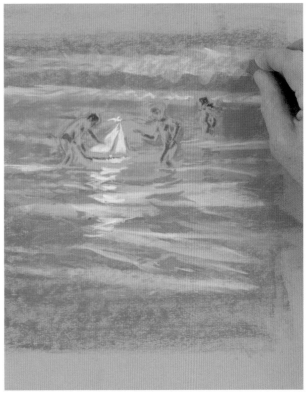

Now use a short piece of pale yellow ocher pastel to draw the sails and the hull of the boat in more detail.

RIGHT Use the same colour for their reflections in the water, where they blend to create further shades of blue and green. With an even lighter pastel (a yellow ocher that is almost white), blend into the reflection to get a few even lighter tones.

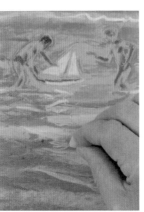

STEP 11 ▸▸

STEP 12 ▸▸

7
playing in the shallows

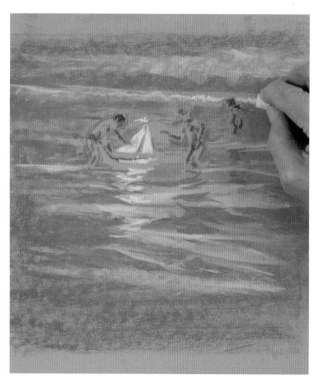

Notice how the white pastel blends with the blues beneath it to give subtle colour shifts, ideal for breaking waves.

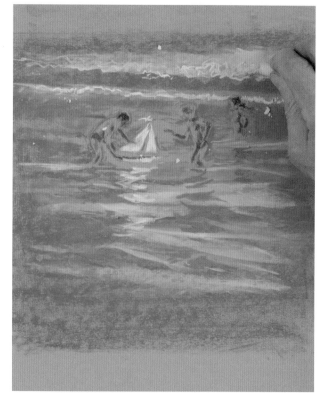

Add sparkle to your painting here and there using a pure white pastel. The white also intensifies the main lines in the painting.

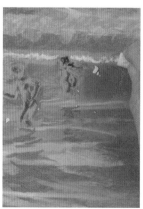

RIGHT If your pastel crumbles a lot, just blow the crumbs away, but do not try to be too tidy. All the grains will contribute to the final construction of the picture.

STEP 13 ▶▶

STEP 14 ▶▶

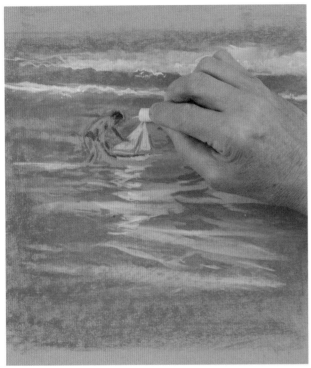

Put some lights onto the figures using just the tip of the pure white pastel. Then use a torchon to soften these highlights down. Notice how this results in an extremely subtle colour shift.

TEXTURE

The texture of the paper you use for your pastel paintings has a great influence on your finished works. On a rough paper surface, there will be places where the pastel sits on top of, rather than sinking into, the grain. This immediately helps you with fleeting subjects such as skies and water.

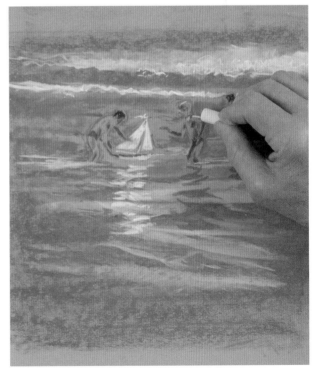

Use the same pure white pastel to widen the sail on the boat.

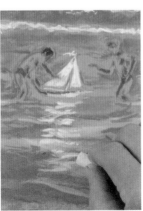

RIGHT Now work some white into the boat's reflections, to brighten them and make them more crisp.

STEP 15 ▶▶

STEP 16 ▶▶

7
playing in the shallows

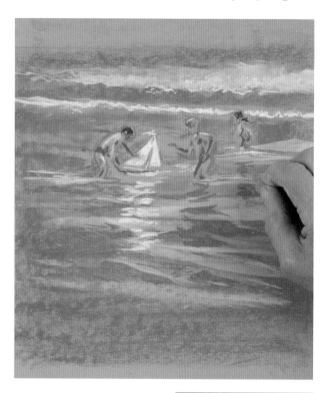

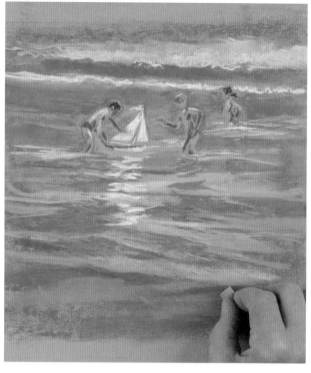

Go back to the reflections of the children you put in at steps 9 and 10. While these were random at first, you can now build on those that work, to create the random pattern of reflections that you are looking for.

RIGHT Use the ultramarine pastel to work some stronger lines around the whites of the waves. This sharpens them.

Bring some darker, warmer ultramarine blue into the bottom of the picture. Then introduce a slightly bluer green to some of the waves. Work across the foreground using a light viridian pastel. Notice how this modifies the colour of the waves, lending a warmer tone to the blues already laid down.

USING YOUR MARKS

In pastel paintings, many of your first, impressionistic marks will remain in your finished painting. However, there will be times when you wish to revisit your first marks. In this project, the reflections of the children were initially sketchy. These were then worked on again, to make them a little more definite.

STEP 17 ▶▶

STEP 18 ▶▶

Work some yellow ocher into the waves. This highlights them, giving them a greater sense of movement. Apply the colour in a fairly linear way in the foreground. Because this colour is laid down over the blues, it takes on a green tinge. Use a torchon to blend the colour around the figures, tidying up their edges and giving them crisper outlines.

REMEMBER

Highlights are not only about adding light colours. You always have the option of refining your lights by adding darker marks in and around them (see step 20).

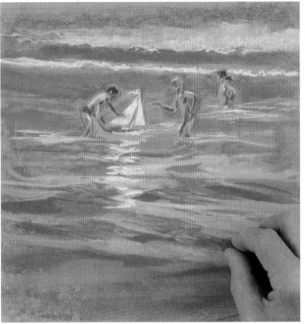

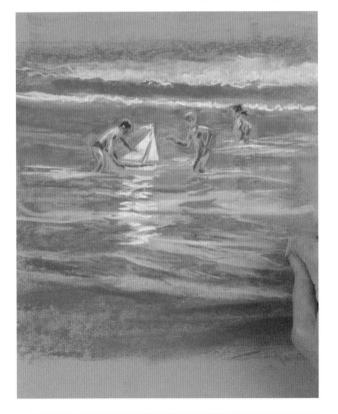

STEP 19 ▶▶

Try chipping some additional dark blue marks into the ocher areas, to make the darks register in the yellow areas. This will brighten the yellow areas by sharpening the contrast between them. Do not get too 'tight' about this: it is generally better to feel that the first mark is the one that you have retained.

RIGHT Add any final details to complete the drawing. Here, a little more ultramarine blue is applied between the figures.

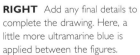

STEP 20

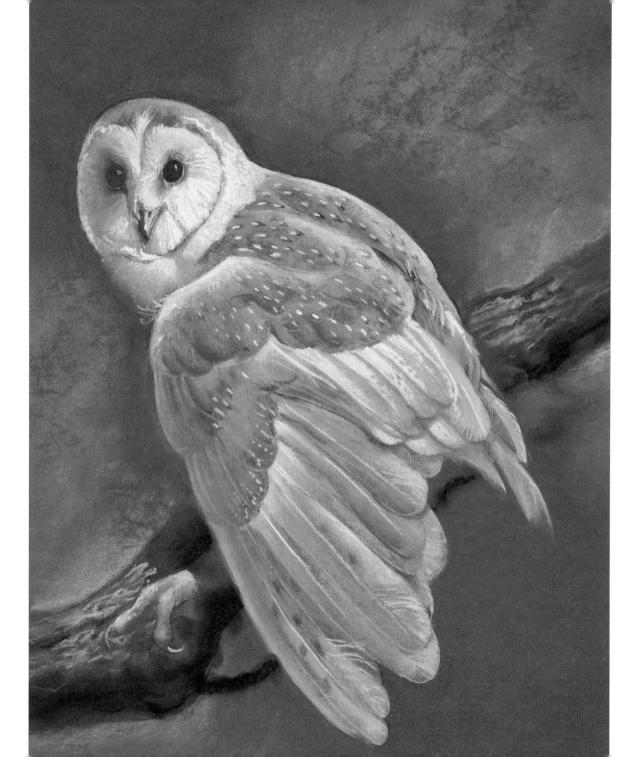

8

barn owl

john barber
500 x 375mm (20 x 15in)

Our fascination with owls and the mythology of their wisdom may have something to do with the fact that, unlike other birds, their eyes face forward and are surrounded by a flat disk. Their beaks are not between the eyes and so seem to be more like a nose. This may be fanciful, but they do have a penetrating stare, as this picture aims to demonstrate. The other characteristic of barn owls that makes them suitable as a pastel subject is that their plumage is incredibly soft, making their flight silent. Add to this the fact that they do look very white when they glide across the sky in the dark and it might explain the sighting of quite a few ghosts in isolated country churchyards.

TECHNIQUES FOR THE PROJECT

Fine line work

Blending to smooth off feathers

WHAT YOU WILL NEED

Grey illustration board
White chalk pencil
Black chalk pencil
Torchon
Scalpel or sandpaper

COLOUR MIXES

1 Payne's gray
2 Viridian
3 Burnt sienna
4 Yellow ocher
10 Violet

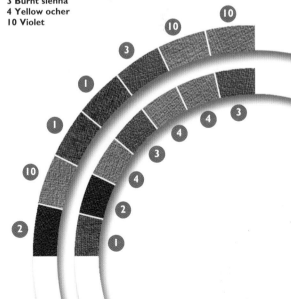

CREATING FINE DETAIL

Pastel is usually not the first choice of painters who want to create works which depend for their appeal on fine detail. But it can produce finely finished effects and render detailed accounts of faces and costumes, as proved by the 18th-century portraitists. In this book, the meticulous portrayal and pebbles and birds' eggs by Brian Gallagher in the gallery shows what the pastel medium is capable of in talented hands. This exercise with the feather shows how to approach detailed work without, of course, completing the process. That will have to wait until you try your hand at a bird painting like the barn owl project. No painting, however detailed, could ever match exactly the intricate nature of feathers. Most artists, when they attempt to paint feathers, show them with gaps and openings and overlapping in the vanes, in a struggle to make it look 'real'. However, single feathers that are taken as models by artists are often molted feathers that are quite damaged and would not help a bird to fly. Coming to the barn owl, which is fairly detailed, it is still just an impression of the bird in which certain facts are established. The first thing was to get the shape of the bird right. No amount of detail lavished on an inaccurate drawing is worth spending time on. It is better to get the shape right and get a few facts about colour and arrangement of feather groups to ring true.

1 Start your feather sketch with the line that will be the quill. From there, take out smooth curves of pastel to start to indicate the individual vanes. This is a very delicate subject, but at this stage you are working with broad swatches of colour.

2 These marks get more delicate as you reach closer to the tip of the feather. When you reach the tip on one side of the quill, start to work a similar set of marks in reverse down the other side of the quill. Use the side of the pastel.

3 Snap the pastel in two so that you can create smaller areas of vanes to create the tip. Work this on both sides. Start at the very bottom and use the white to get some roundness into the base of the quill. Then work up the quill.

4 The pure whites now need to be blended in so take a clean torchon and use this to as your blending tool. Strengthen the feathers at the base of the quills. Blend the very soft edges of the tendrils away, almost to nothing.

5 Work many, many parallel lines to blend from light to dark. You don't want to lose all the texture of the paper, but because feathers are so delicate, you do not want to make them too solid. Do some fine linework near the bottom of the quill.

6 Then take the black chalk pencil and use it to re-define some of the edges. Softening has lost some of the drama of the feather. The pencil will also help to clean up some of the drawing edge, refining the shape of the edges of the feather.

8
barn owl

Trace the main outline of the subject as accurately as possible using white chalk. Do not worry about extra chalky marks, as these will be covered up when you start to work with the pastels. As with all portraits, it is important to get the eyes right to start with. Put them in using the black chalk and flatten the colour at the edges with a torchon. You will add highlights later.

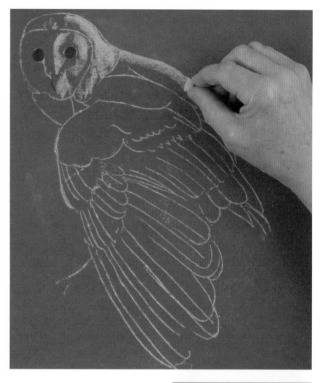

Start to define the lighter areas of the subject, using a short piece of violet-grey pastel. Work with it on its side, applying colour in a sweeping motion. These areas will stand out from the darker board, revealing its texture.

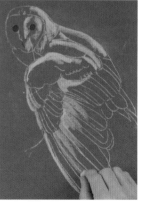

RIGHT The light on the feathers is soft. In this case it is coming from the top right so that shadows cast by the feathers will be on the left. These shadows are only slight but important.

STEP 1 ▶▶

STEP 2 ▶▶

Having established the main areas of light, start to blend them using a torchon, your finger, or a rag in a slightly circular motion. The idea is to blur all the marks to achieve a slightly modulated tone. See how, with just one pastel on a tinted board, you can establish clearly the form of the owl. The now chalky index finger acts as a drawing tool to spread the colour around. Do not worry if your finger moves some colour into the background at this stage.

BE CONFIDENT

The advantage of using your finger as your blending tool is that you can feel the texture of the board and apply as much pressure as you need. You do not want textures at this stage – they will be added later – for now, your concern is simply laying in the lights and darks.

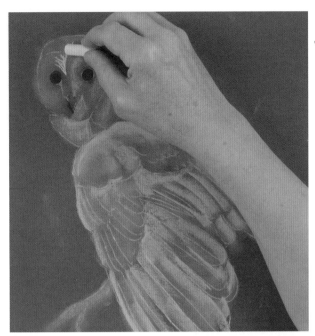

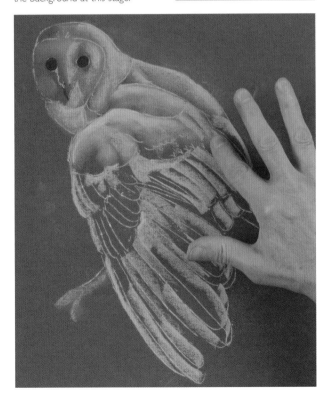

Take an even lighter pastel with slightly more blue in for the more precise marks on the face. Use the corner of the pastel and lightly push the colour on.

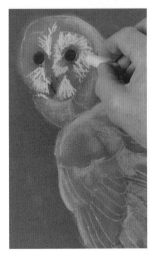

RIGHT Radiate your marks out from the eyes – this is how the feathers grow. Start to blend the pastel using a torchon or cottonbud. Each time you blend, you get more pastel into the board. You also get back to the darks. This is deliberate, as you will create the lightest highlights in the final stages of the drawing.

STEP 3 ▶▶

STEP 4 ▶▶

8
barn owl

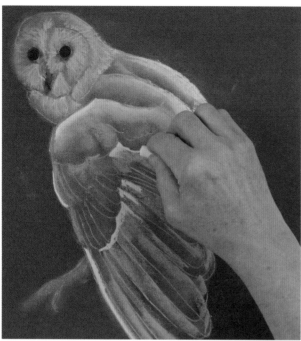

RIGHT Having established the main areas of feathers, turn to burnt sienna and yellow ocher to start tinting them. Introduce colour without losing the light and shade you have built up.

You can create quite precise marks, if you use the edge of the pastel. Some of the colour will be too strong, but establish where it should be, then tone it down.

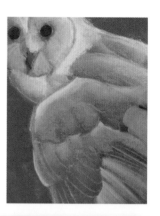

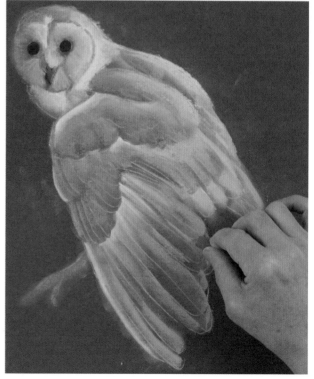

Continue to add colour in this way, laying the pastel on and blending it with a torchon or your finger. Re-establish your outlines as you work: you do not want to lose the basic drawing.

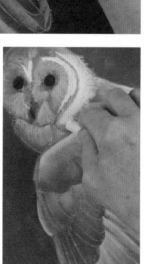

RIGHT Any texture of the chalk on the board is not helpful at this stage, so blend every time you add more colour.

STEP 5 ▸▸

STEP 6 ▸▸

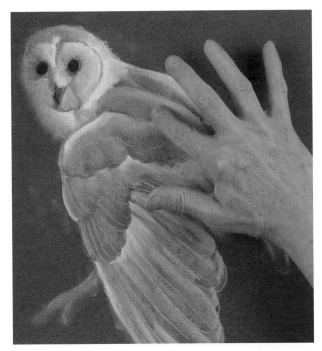

RIGHT Introduce more detail to the face. You may have to sharpen a pastel to make the finest lines. Either use a scalpel blade or a piece of sandpaper to get a sharp point.

Taking care not to put your hand on your work, use the pointed pastel to introduce some detailed lines. You may have to make many little parallel lines to establish the areas of light before blending them with a torchon.

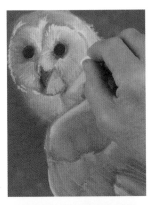

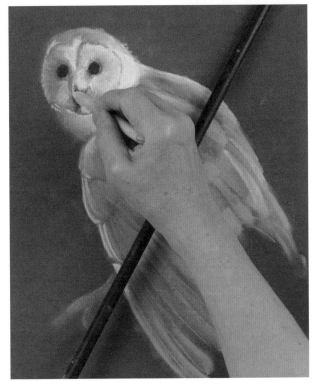

The colours of feathers vary from species to species of owl, but if you limit your palette to these colours, the bird will not start to look too ginger. Soften the yellow ocher and burnt sienna tones by blending them using your finger.

RIGHT Do not be nervous about rubbing too hard as you blend the colour: a certain amount of pressure is required for the best results.

STEP 7 ▶▶

STEP 8 ▶▶

8
barn owl

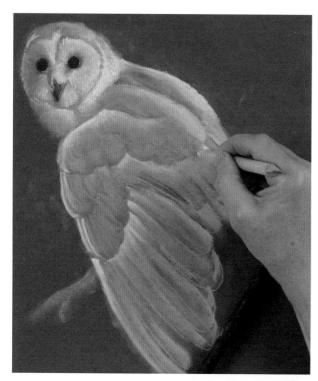

RIGHT Introduce some mottling on the feathers using a fairly dark Payne's gray. Drag and blend the pastel to create the right effect. Define the edges of the feathers using a black chalk pencil.

In areas that are too fine to render using a pastel – around the edges of the feathers and in the shadows they cast – use the pencil. Work with the existing pastel, so that the black chalk does not stand out as a separate medium in the finished painting.

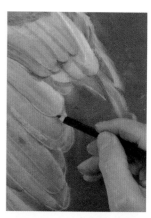

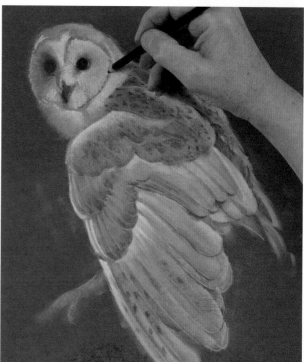

Create shadows where they are needed on your painting using a pointed torchon. Push the pastel away from the board, re-defining the shapes by lifting out colour. The torchon will not make your drawing as dark as the original board, but give you a soft shadow.

RIGHT Use the torchon to mark out the subtle shadows cast by one feather onto another. Stop at regular intervals to sharpen the torchon so that you have a clean area with which to work.

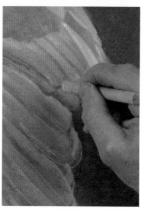

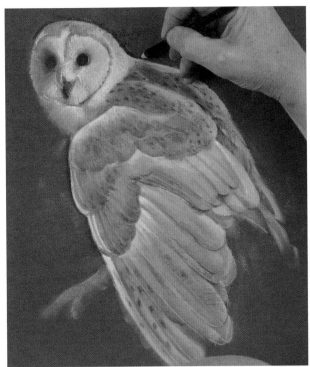

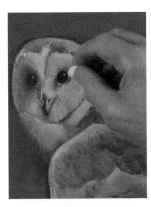

RIGHT Take a white pastel with a sharp point and work some detailing on the head, bringing the bird to life.

Establish highlights on the lower wing feathers using pure white, leaving grey for the shadows. This gives a more three-dimensional look to the feathers.

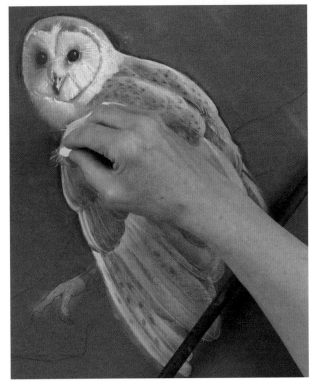

Now use the chalk pencil to clean up the outline of the owl, bringing a crispness to it. Blur your lines with a clean torchon.

RIGHT With the burnt sienna pastel, introduce a slightly redder tone into some of the feathers. This has the effect of warming the whole piece. Do not blend this colour too much, as you risk losing the delicate detail you have built up underneath. Use the same colour around the eye and for the owl's beak.

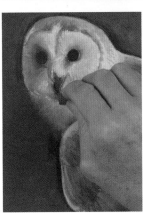

STEP 11 ▶▶

STEP 12 ▶▶

8
barn owl

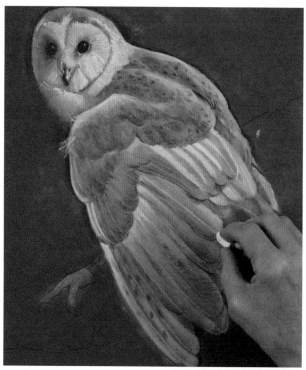

You will have drawn an outline of the owl's foot in step 1 (see p. 148). Now begin to put some textured chalk on it. The claws are feathered and the feathers are very white.

(see p. 148)

PADDED GROUNDS

When working on thin papers, put some sheets of paper on your drawing board first. This gives a soft, quilted feel and means your pastels are less likely to snap. It also prevents any texture from the board underneath coming through into your painting.

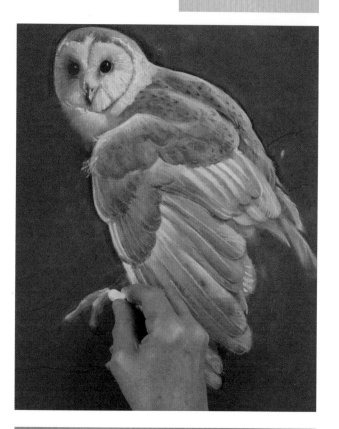

Introduce some white on the right-hand edges of some feathers. Be careful not to overdo this, however, as the feathers will stand out too much.

RIGHT Simply draw a fine line, using the sharpened point of the pastel and blur it using your finger.

STEP 13 ▸▸

STEP 14 ▸▸

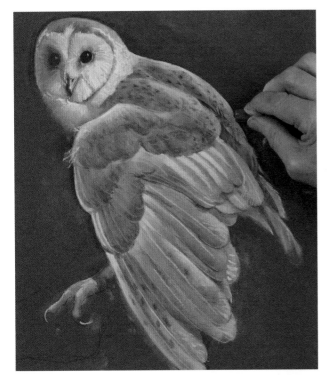

Now take an olive green that is not too bright and use this to work some texture into the branch. Drag the pastel around the board to give an indication of texture. There is no need to see the branch in any great detail, but you can draw into the green using a Payne's gray pastel to give an impression of the bark.

FIXING PASTELS

If you do not want to spray your painting to fix the pastels as you work, you could instead lay a sheet of acetate over the surface and press a board down on it. This will help to crush the pastel into the paper surface, so that spraying becomes unnecessary.

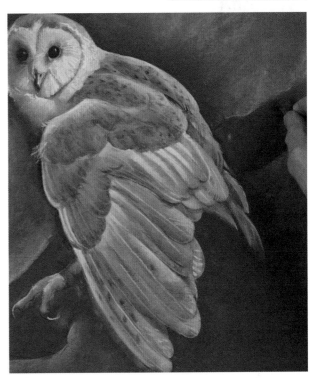

Use a dark viridian to help pick out the bird from its background. This eliminates the black colour and gives the piece some texture. Work the tip of the pastel around each feather, giving it a smooth curve and eliminating any ragged edges.

RIGHT To get some interest into the background, start to mix some violet into the green. You do not want the background to look too 'dead'.

STEP 15 ▸▸

STEP 16 ▸▸

8
barn owl

RIGHT Lay down some more colour on the background, working the violet pastel into the dark viridian as before.

Use a lighter green to put in some moss and lichen on the branch. Do not attempt to outline every highlight, but give an indication of where light might be catching the moss on the branch.

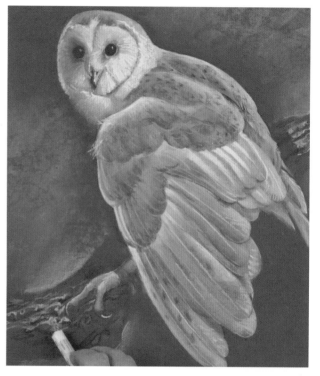

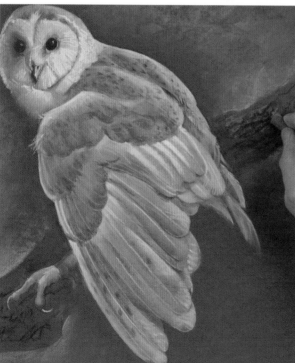

Take a yellow-green pastel and use just the tip to indicate touches of light on the branch. Do not overdo this: less is better than more. Soften these marks with the edge of your finger where you want to.

CLEAN PASTELS

Pastels, if laid down together, can become contaminated or made dirty by rubbing against other pastels. You can clean these up by shaking them gently in a jar full of dry rice grains. Some people store all their short pieces of pastel in this way. It also stops them from breaking.

STEP 17 ▶▶

STEP 18 ▶▶

RIGHT Add lights to the feathers, using pure white and making those in the shadows less strong. Do not try to make all your feathers bright, simply select those that catch the light.

Use your darkest ocher pastel to accentuate some of the darker edges. Blend this in so that you get an impression of one feather overlapping another.

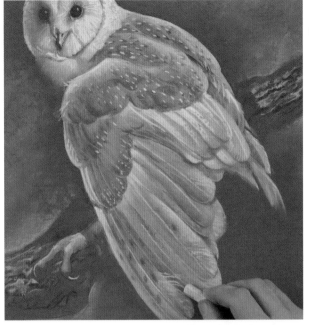

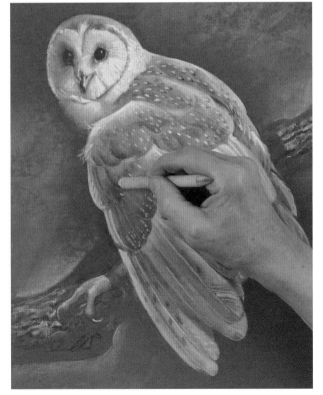

Finally, add a few white lines at the bottom to indicate feathers that may be split, or that do not quite overlap those next to them.

RIGHT As a finishing touch, soften the edges of the feathers on the left – pulling them out of the shadows – and blend the colour on the branch.

STEP 19 ▶▶

STEP 20

index

index

Author's acknowledgments

I would like to thank my wife, Theresa, for her loving
support during the countless hours I spent in the
studio preparing this book.

Publisher's acknowledgments

Axis Publishing would like to thank London Art
Limited, 132 Finchley Road, London NW3 5HS for
the loan of materials for photography.
www.londonart-shop.co.uk